ROBERT MAPPLETHORPE
THE PERFECT MOMENT

JANET KARDON

INSTITUTE OF CONTEMPORARY ART
UNIVERSITY OF PENNSYLVANIA

WITH ESSAYS BY
DAVID JOSELIT AND KAY LARSON
AND
DEDICATION BY PATTI SMITH

This exhibition and publication have been made possible in part by grants from Mr. and Mrs. Harold A. Honickman; the Dietrich Foundation; the Robert Mapplethorpe Foundation, Inc.; the National Endowment for the Arts; the Pennsylvania Council on the Arts; and the City of Philadelphia.

ISBN 0-88454-046-4
Library of Congress cataloguing in publication data.
Kardon, Janet
Robert Mapplethorpe/Janet Kardon; with essays by David Joselit and Kay Larson and poem by Patti Smith.
Library of Congress catalogue card no. 88-82778.

Design: Dimitri Levas
Typography: Duke & Company
Printing: Meriden-Stinehour Press

Third edition 1990

Front cover: *Calla Lily*, 1986, silver print, 40″ × 40″, collection the estate of Robert Mapplethorpe.

Back cover: *Skull*, 1988, silver print, 24″ × 20″, collection the estate of Robert Mapplethorpe.

CONTENTS

EXHIBITION ITINERARY

INSTITUTE OF CONTEMPORARY ART
UNIVERSITY OF PENNSYLVANIA
PHILADELPHIA, PENNSYLVANIA
DECEMBER 9, 1988–JANUARY 29, 1989

MUSEUM OF CONTEMPORARY ART
CHICAGO, ILLINOIS
FEBRUARY 25–APRIL 9, 1989

CORCORAN GALLERY OF ART*
WASHINGTON, D.C.
JULY 1–SEPTEMBER 3, 1989

WASHINGTON PROJECT FOR THE ARTS
WASHINGTON, D.C.
JULY 21–AUGUST 13, 1989

WADSWORTH ATHENEUM
HARTFORD, CONNECTICUT
OCTOBER 21–DECEMBER 24, 1989

UNIVERSITY ART MUSEUM
UNIVERSITY OF CALIFORNIA, BERKELEY
JANUARY 17–MARCH 18, 1990

CONTEMPORARY ARTS CENTER
CINCINNATI, OHIO
APRIL 8–MAY 21, 1990

INSTITUTE OF CONTEMPORARY ART
BOSTON, MASSACHUSETTS
JUNE 14–AUGUST 31, 1990

*On June 12, 1989, the Corcoran Gallery of Art withdrew
from the exhibition tour.

ACKNOWLEDGMENTS

The Institute of Contemporary Art, University of Pennsylvania, is dedicated to presenting exhibitions that reflect significant issues of the art of the present and recent past. Although ICA has organized thematic exhibitions that have featured a number of photographers, "Robert Mapplethorpe: The Perfect Moment" marks the first occasion that the Institute of Contemporary Art has originated a one-person photography exhibition. Unquestionably, the artist has produced a body of work warranting such a level of intensive examination and documentation. This exhibition of his work, the largest to date, is the first to travel to several venues; it includes works from 1970 through 1988, with a particular emphasis upon the artist's unique objects.

Significant support from many individuals and public agencies has made the exhibition and catalogue possible. We are enormously grateful to Lynne and Harold Honickman, the Dietrich Foundation, the Robert Mapplethorpe Foundation, Inc., the National Endowment for the Arts, the Pennsylvania Council on the Arts, and the City of Philadelphia. Especially we wish to thank the lenders who have agreed to part with their works for an extended period in order for the exhibition to travel.

The illuminating, provocative essays of Kay Larson and David Joselit and the reflections of Patti Smith have greatly enhanced this catalogue. I also wish to acknowledge Robert Mapplethorpe's contribution and direct involvement with the contents of this publication by allowing me to interview him and by reviewing my edited versions of our discussions.

It has been a source of great pleasure to work with our colleagues at the recipient museums: Michael Danoff, former director, and Bruce Guenther, chief curator, Museum of Contemporary Art, Chicago; David Ross, director, and Elisabeth Sussman, curator, Institute of Contemporary Art, Boston; Christina Orr-Cahall, director, and Jane Livingston, associate director, Corcoran Gallery of Art, Washington, D.C.; Patrick McCaughey, director, and Andrea Miller-Keller, curator of contemporary art, Wadsworth Atheneum, Hartford; and James Elliott, former director, Jacquelynn Baas, director, and Susan Teicholz, curator of exhibitions, University Art Museum, Berkeley.

I welcome this opportunity to express my appreciation to ICA's exhibition committee, chaired with outstanding discernment by Daniel W. Dietrich II. The committee expressed unbounded enthusiasm for this project from its first presentation, and the entire advisory board also shared that same commitment.

By their very nature, projects as complex as this are collaborative efforts, and I am fortunate to have enjoyed the assistance of an especially dedicated and able team of collaborators. The Robert Miller Gallery has provided much assistance, and I am grateful to Robert Miller, Howard Read, and Susan Arthur. Suzanne Donaldson, at the Robert Mapplethorpe studio, has been untiring in her efforts. This project depended upon her knowledge, but her patience and good humor were unexpected benefits. Tina Summerlin was extremely dedicated and Brian English was very helpful in attending to the many details that the exhibition generated. Dimitri Levas has participated in this project in many crucial ways, particularly in his expert design of the catalogue. Our editor, Gerald Zeigerman, has brought his usual diligence and expertise to the text, which was carefully composed by Duke & Company, Typographers.

ICA's staff has devoted considerable time to the project. Judith Tannenbaum, ICA's assistant director, has expertly overseen many aspects of the project with her customary insight and effectiveness. Andrew O. Robb, acting curatorial assistant, researched and compiled the bibliography, exhibition history, and checklist. Jane Carroll, registrar, performed her own assignments as well as many others with goodwill and attentiveness. Arlene Sciole, former assistant to the director, brought a sense of order to every assignment and to my own work. Nancy Burd, chief development officer, and her assistants, Nanita Barchi, Rosemarie Fabien, and Leslie Fontana, contributed their best efforts. Fran Kellenbenz, business administrator, aided by Andrea Kaplan, dealt with a myriad of financial details. Michelle de Guzman, volunteer, and Robin Beckett, intern, helped with research. I am very grateful for their invaluable assistance.

I first met with Robert Mapplethorpe early in 1987 to discuss the possibility of this exhibition. From the beginning, Robert was totally cooperative and always encouraging, and at every stage of the project he provided appropriate support. I am deeply grateful to him for the insights he offered on his work, his steadfast commitment to this project, his generosity with his time, and his astute and memorable observations in our discussions of a vast spectrum of ordinary and sublime matters.

Janet Kardon
Director
Institute of Contemporary Art

LENDERS TO THE EXHIBITION

John D. Abbott, Jr., New York

Barbara and Bruce Berger, New York

Lois and Bruce Berry, Chicago

Evelyn Byrne, New York

George Dalsheimer, Baltimore

G. H. Dalsheimer Gallery, Baltimore

Anne and Joel Ehrenkranz, New York

George and Betsy Frampton, Washington, D.C.

Sondra Gilman and Celso Gonzalez-Falla, New York

Mr. and Mrs. Harold A. Honickman, Rydal, Pennsylvania

Lynn Hurst, Houston, and John Van Alstine, Jersey City

The Israel Museum, Jerusalem

Emily Fisher Landau, Rye, New York

Dimitri Levas, New York

Harry H. Lunn, Jr., New York

Estate of Robert Mapplethorpe, New York

Andrew and Betsy Rosenfield, Chicago

Private collections

ROBERT
MAPPLETHORPE

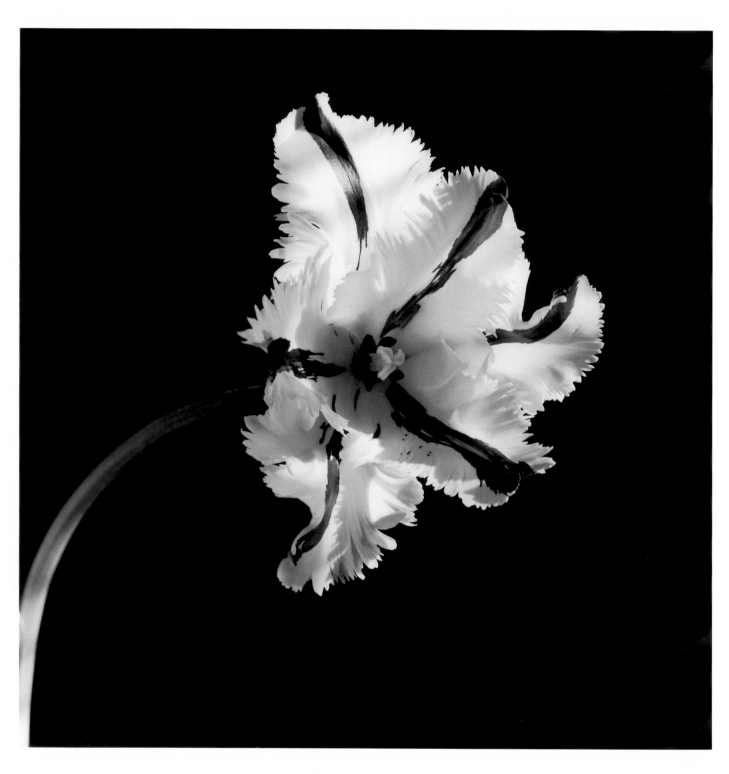

Parrot Tulip, 1987

JANET KARDON

THE PERFECT MOMENT

Robert Mapplethorpe's first one-person exhibition, at New York's Light Gallery, in 1976, was composed of Polaroid photographs of flowers, portraits, and erotic images. Twelve years later, the artist is still focusing upon these three traditional genres: the still life, the portrait, and the human figure. Circumventing the snapshot and documentary photograph, his astute social observations have included contemporary luminaries as well as radical sexual activities. He has extended photography's parameters by incorporating fabrics with photographic imagery in diptychs and triptychs, allowing his work to be perceived within the territories of painting and sculpture. Mapplethorpe's work does not follow a developmental streak, but it does appear predetermined. Since the midseventies, the work has evidenced singularity and maturity.

Mapplethorpe's range is extensive. He has photographed a single, elegant blossom as well as flower arrangements, black male models and a female bodybuilder, earthy portraits of the art world and glamorous celebrities. In his self-portraits, he has depicted himself as both gunman and dandy. He has collaged found-pornographic imagery, staged his own provocative mise-en-scènes, and, on occasion, portrayed children and landscapes. He has also created abstract wall reliefs, designed record album covers and furniture, and conceived shoots for liquor advertisements, fashion magazines, and deluxe interior design publications devoted to our more conspicuous life-styles. Within this spectrum, it is remarkable that Mapplethorpe's classical subjects, as well as his excursions into other contexts, exude a seamless and unique vision.

Mapplethorpe first conceives his artworks as Polaroids, or sixteen- by twenty-inch silver prints, or Cibachrome prints on paper, but some images, granted an afterlife, may reappear in a larger size or as platinum prints on linen. Certain subjects enter the realm of unique objects when they are presented in precisely designed and well-crafted frames or in combination with fabrics in the diptych or triptych format. This exhibition is centered on the classical themes—still lifes, portraits, and figure studies—and places special emphasis upon the unique objects. Some wall reliefs that do not incorporate photographic images are included as well.

A committed formalist, determined to distill the most beautiful aspect of any subject, his work interacts with particular photographers who work under carefully controlled studio conditions. A. D. Coleman called this a "directorial mode," in which "the photographer consciously and intentionally *creates* events for the express purpose of making images thereof."[1] Mapplethorpe's own collection, much of which he sold in 1982, focused upon formalist late-nineteenth-century and early-twentieth-century works, particularly photosecessionist and pictorialist photography.[2] His own images are the prodigious offspring of Julia Margaret Cameron and Nadar portraits, Weston vegetables, Man Ray condensations, Cecil Beaton black figures, and F. Holland Day youths, all effectively mutated into exquisite contemporary hybrids by his courageous attitude toward sexuality and an eighties imperative for significant scale.

Mapplethorpe's directorial mode demands specific artifice. Like Nadar, he takes most photographs in his studio against photographic backdrop paper. There is drama in each photograph; edges are used as the perimeters of a proscenium, with subjects strategically sited within these boundaries and caught at a moment of absolute stasis. Most sitters are portrayed frontally, aligned with the camera lens, in direct eye contact with the photographer and, in turn, the viewer. Nudes generally assume classical poses. Flowers are not allowed an affinity with nature's organic chaos but are frozen into perfect symmetry or a precisely balanced asymmetry. Mapplethorpe is a rigorous director; his austere studio conditions allow few of life's messy intrusions to clutter the sparse presentation of his subjects. Photographic information is severely limited; the photographer's aesthetic, which leans heavily upon proportion and composition, borrows from Mies van der Rohe: *Less is* indeed far *more*. Despite minimal studio backdrops, even stoic constraints, Mapplethorpe has produced some of the most luxurious, seductive, and memorable images in photographic history.

THE NUDE: Mapplethorpe first received attention, even notoriety, in the early seventies, for collages that incorporated images scavenged from pornographic magazines. These were followed by his own studies of black male models.

It is an enormous challenge to photograph darkness, for the photographer's most reliable partner is ambient, directed, or reflected light. Mapplethorpe's specific skills enable him to manipulate studio light in order to capture the discrete texture and density of black skin—to chart a dark terrain he has often called "bronze." Although there are hundreds of such images, he has relied upon a mere handful of men as subjects, putting each of them through a vigorous repertoire of classical poses interspersed with sexual and provocative postures. Often, they are called upon to role-play: to wear a crown of thorns; display themselves; or act out homosexual S & M events. The black models are very black, and often are portrayed against very *white* grounds, paralleling, even emphasizing, the inherent quality of black-and-white silver prints. Figures are startlingly volumetric, occupying their space so convincingly that the photographer might be holding a chisel instead of a camera.

One cannot avoid the homosexual implications of Mapplethorpe's work. Male nudes of any color or race when photographed by another male would invite this interpretation, but Mapplethorpe's signals may be more complex. Although his models often are depicted in uncommon sexual acts, the inhabitants of the photographs assume gestures governed by geometry, and they are shown against minimal backgrounds. The underlying formal imperative of any Mapplethorpe image can sufficiently unsettle the viewer to activate a sense of disbelief, since the circumstantial evidence is contradicted by the presentation. How can the subject—stultified by symmetrical, frontal, canonical poses, and removed from real life by dramatic light of high contrast—really be homosexuality? The scenes appear to be distilled from real life; when elevated to an unnatural innocence, they create a frisson between the licentious subject of the photograph and its formal qualities that purifies, even cancels,

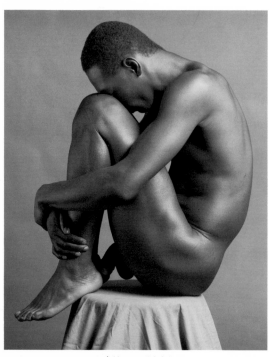

Ajitto, 1981

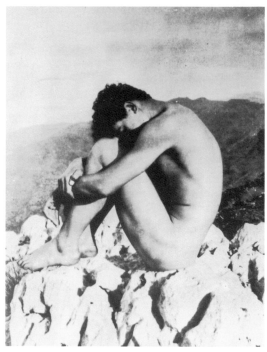

Wilhelm von Gloeden, 1890

Ajitto is one of Mapplethorpe's black models. There are four studies of him crouched upon a pedestal, in frontal, rear, and side views, assuming the attributes of pedestal sculpture. The distance of the lens from the subject delivers the precise scale to ensure this impression. (Among Mapplethorpe's photosecessionist works was a Baron von Gloeden male nude in a similar classical pose.) Mapplethorpe's imposition of stasis and his proclivity for smooth-skinned, perfectly proportioned, if slightly rotund, models delivers the aura of classical Greek marbles. His brand new "artifacts" recall that moment in antiquity before the Romans leaned toward the idiosyncracies of portrait sculpture. Idealized body fragments—an arm, torso, rear view—also underline Mapplethorpe's affinity with the Greeks. But Greek canons probably entered Mapplethorpe's work through modern derivations—a Minor White rear view of a male nude or a Walery study of an outstretched arm, for example, both of which were in Mapplethorpe's photograph collection.

the prurient elements. This dialectic is underlined further by Mapplethorpe's use of the most intense whites and densest blacks. Depicting blatant sexuality in a pristine photographic language infuses these works with enormous impact and energy; the contrast between the subject and its manner of presentation allows the viewer the option of being either voyeur or connoisseur. In either instance, the images remain potent entrapments.

The display of Mapplethorpe's S & M photographs in the conventional gallery or museum environment can be startling; it can also afford the viewer conflicting signals. But Mapplethorpe may purposely use distraction as an antidote for scatalogical images. As Barthes noted, "Mapplethorpe shifts his close-ups of genitalia from the pornographic to the erotic by photographing the fabric of underwear at very close range: the photograph is no longer unary, since I am interested in the texture of the material."[3] A good example of this particular tactic is found in *Man in Polyester Suit* (1981)

(p. 69), which shows the torso of a man wearing a three-piece suit. When the photograph is displayed on a wall at the customary height, the penis extends from the open fly at eye level. The presentation mode is that of a clothing advertisement, which makes the appearance of the penis even more unsettling. The photograph catches the viewer in a binary pull: The action cannot be perceived unless the eye constantly darts in opposite directions as in a tennis match, or, in this instance, between the mundane polyester suit and what outrageously protrudes from its trousers. Lurking within the conception of such photographs is a cunning and urbane humorist, always ready to surprise and outwit the viewer.

In addition to his studies of black male models, Mapplethorpe, between 1980 and 1982, produced more than one hundred photographs of Lisa Lyon, a white female bodybuilder and champion weight lifter.[4] Their alliance afforded a fertile opportunity to focus upon gender ambiguities, since both subject and auteur were inclined to subvert feminine and masculine stereotypes. The result of the collaboration is a study in presentation modes. A bodybuilder is a disembodied performer; as the bodybuilder completes a routine repertoire, the self is often sublimated amidst demonstrations of the body's feats.

Mapplethorpe enlisted the common techniques of theatrical artifice—costume, makeup, hairdos, props, lighting—to transform his adaptable sitter. Lyon cooperatively assumed a formidable lexicon of feminine personas, punctuated by unsettling masculine interjections. Even the title of the series, *Lady, Lisa Lyon*, has dual implications. Is she a lady of the night, or a proper white-gloved lady removed from any sexual inclinations? Mapplethorpe's photographs of Lyon are reminiscent of Michelangelo, who endowed both sexes with masculine musculature. But the Lyon studies demonstrate, perhaps more than any of Mapplethorpe's pursuits, his talents as an impresario, his ability to *create* images. Obviously, Lyon was a willing and malleable subject with theatrical aspirations, but the range of characters that Mapplethorpe elicited is remarkable: He discovered some of her latent personas and probably invented others.

STILL LIFES: The still lifes are primarily studies of a single flower or clusters of the same variety, tastefully arranged in vases from the artist's collection and shown against sparse backgrounds. That he collects glass and pottery containers invites a Freudian interpretation. Are these vessels analogues for a desired but missing anatomical part: the vagina? Are these objects sublimations for the stereotypical feminine qualities of enveloping, enfolding, embracing, containing? Or, since both men and women do collect containers, are gender differentiations irrelevant?

There are several crucifixes as well as depictions of the Crucifixion in Mapplethorpe's collection. His exhibition at Robert Miller Gallery, in 1983, featured geometric wall reliefs, several of which were crosses. Yet, of all Mapplethorpe's subjects, the flowers offer the greatest evidence of his Catholic background. Most of his still-life compositions are symmetri-

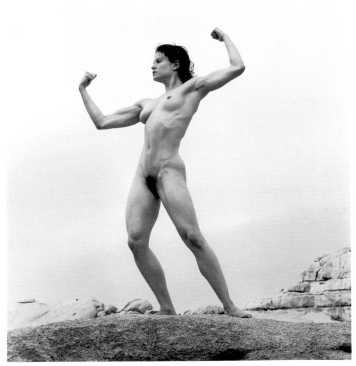

Lisa Lyon, 1980

cal; the flowers occupy the center of the photograph (and only occasionally will they peer in provocatively from the outer edges). Because flowers are presented in a state of absolute perfection, they suggest a realm more sacred than profane. These blossoms seem to emerge from a rarified atmosphere in which Nature, like Heaven, is in array. This sense of order infiltrates every Mapplethorpe composition. In his home, every object has its place. His remarkable collection of glass and ceramic vases from the fifties is aligned on shelves in as dramatic a manner as his still lifes occupy the photographic surface, or as precisely as sacred objects are sited on an altar.

Neither a medieval icon nor a Mapplethorpe flower reveal much background information. Mapplethorpe's flowers, divorced from nature and set against stark backgrounds, are similar to such icons as a medieval Madonna depicted against an unnatural, gold-tooled ground, far removed from any earthly smudge. Without the slightest tinge of historical decay (flowers and fruits have traditionally been enlisted to evoke a vanitas theme), Mapplethorpe's flowers are always captured at the moment of perfection. Each flower's petals, like slivers of alabaster, both absorb and emit light.

Mapplethorpe portrays flowers not as benign, pretty objects but powerful sensuous presences; the seductive rendering only thinly disguises their menacing undertone. In addition, the flowers that he chooses to photograph possess a symbolic pungency or threatening form: lilies, cacti, baby's breath, birds of paradise, orchids. (The word "orchid" is derived from the Latin root "orchis," which means "testicle.") These flowers achieve their place in Mapplethorpe's vocabulary because of their iconic presence: A single lily's open petals may be read as an open hand or a manacle. His flowers emerge from darkness to aggressively occupy the photograph's surface; their petals thrust toward the viewer; their erect,

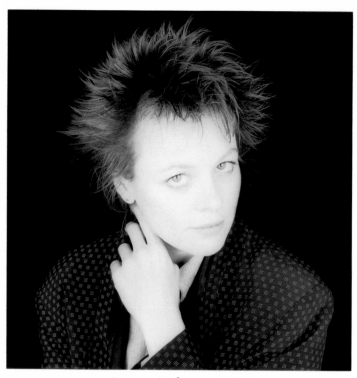

Laurie Anderson, 1987

larger-than-life stamens appear with the chilling unexpectedness of an open switchblade. Mapplethorpe also created a series of wall reliefs that incorporated knives and daggers, which he mounted disarmingly in heart-shaped frames.

Arrangements of several flowers convey the abundant and *uncontrollable* growth of a jungle. His fascination with the dark side, with evil, most obvious in the figure studies, is manifested as well in the flowers. On many occasions, Mapplethorpe has photographed lilies—flowers that often carry a heavy, sweet scent, but whose reproductive organs, pistil and stamens, protrude aggressively from sharply pointed petals. This is the flower that symbolizes the Madonna's purity; for Mapplethorpe, it represents a seductive, perhaps demonic, Antichrist. His lilies, like many of his other subjects, are intentionally bilingual.

PORTRAITS: Mapplethorpe's editioned portraits are primarily of figures prominent in the arts or society.[5] His subjects are not intended to represent the diversity of a "family of man," but under his relentlessly focused direction, they might be part of the same family tree.[6]

The artist maintains control; each sitter becomes the avatar for *his* vision. Photographic backdrop paper shuts out the disruptions or irregularities of daily life, and only rarely does an identifying symbol or iconographic baggage accompany a sitter, as in traditional portraiture. Just as Andy Warhol thought everyone deserved fifteen minutes of stardom, Mapplethorpe provides the inimitable moment of glamour when he embeds each sitter into history at his or her most attractive.

The imperfections of physicality—a prominent feature, wrinkle, skin eruption—are polished and faceted by Mapplethorpe's imperatives, yet he delivers renderings that are far stronger than standard celebrity portraits. The masterworks he makes from nuances of social behavior or a sitter's individual presentation style possess the subtle and memorable power of a Henry James characterization—wherein descriptive details accumulate slowly until they suddenly erupt in a quiet yet powerful revelation. Mapplethorpe maintains control, but he also engenders each subject with the confidence to confront the camera and, hence, the viewer with forceful conviction. Unlike *The Picture of Dorian Gray*, a Mapplethorpe portrait is more perfect than the sitter, and it will remain unchanged—although the sitter may decay as the ravages of time, if not evil, intervene.

Most portraits are taken in Mapplethorpe's studio; some subjects, though, are portrayed in their work or domestic environments. Whatever the location, a staged quality mediates the sitter's personality and Mapplethorpe's vision into perfect accord. Susan Sontag, in commenting on Mapplethorpe's portraits, observed that he portrayed "not the truth about something, but the strongest version of it."[7] Actually, the strength of a Mapplethorpe portrait—and whatever aura of veracity is conveyed—is the result of precise procedures. Sitters, like still lifes, have to be prepared for presentation to the camera. Makeup must be applied and hair professionally combed; props are not made available and individual gestures are not encouraged. Mapplethorpe sites the subject at a predetermined distance from the camera and directs her, or him, to rotate the head slowly—but eyes must always remain fixed upon the lens. He hypnotizes, even mesmerizes, the subject, beckoning for the head to turn in a certain direction, and then somehow "moves" it, as if by magnetic force, in another direction. Thus, he captures his subjects at total attention, and, since life's vagaries are never permitted to mar the moment, sitters are portrayed, like the flowers, in their most perfect state. These portraits are not piercing distillations of each sitter's persona but a confirmation of Mapplethorpe's relentless vision, which allows depictions of the sitters that mirror *their* most perfect selves.

Mapplethorpe's self-portraits, as might be expected, never catch the photographer off guard. Personas are adapted to fulfill a current imperative: Mapplethorpe as transvestite, leather-clad gunman, horned devil, or black-tied dandy. Whatever the assumed role, an attitude of challenge and aloofness emanates from the pose; it is the viewer who is caught off guard and outstared. The urbane sophistication is there—the remarkable charm and appeal of the director, the auteur, the impresario who makes the viewer the victim of his stare. This stare is no more effective than in a self-portrait of 1988. From the densest of dark grounds emerges a thin and pale, yet potent, personage. In his hands, he clasps a walking stick; its handle is a skull. Side by side, both skull and face confront us. We meet the eyes of Mapplethorpe, and the eye cavities of the skull, across an immeasurable chasm.

It is true that a consistent vision permeates every Mapplethorpe photograph, be it still life, nude, or portrait. Full-bodied flowers as well as provocative models deliver potent seductive messages; such signals resonate throughout the works. Mapplethorpe makes a point of *not* distinguishing

between his flower studies and his pornographic imagery. A flower—poised, open, awaiting the bee—is an analogue of sexual readiness. Black nudes, male couples, a bodybuilder's perfected body, Patti Smith's straightforward gaze—they all offer themselves. Mapplethorpe uses the medium of photography to translate flowers, stamens, stares, limbs, as well as erect sexual organs, into objets d'art. Dramatic lighting and precise composition democratically pulverize their diversities and convert them into homogeneous statements. Yet Mapplethorpe's language is consistently contradictory. The flowers exude beauty *and* danger, the nude black models epitomize purity *and* eroticism, the portraits convey truth *and* deception.

Different subjects, Mapplethorpe feels, do not alter the essence of his photographs, the perfection with which he cloaks every subject. What is the essence, the final message, of a Mapplethorpe photograph? There is a clarity, a stillness (as if the subject had been photographed *before* the photograph was taken) that imbues each work with a sense of timelessness: It isn't evening or morning, or early or late, or now or then, but some moment, not just before, or during, or after. Mapplethorpe captures the peak of bloom, the apogee of power, the most seductive instant, the ultimate present that stops time and delivers the perfect moment into history.

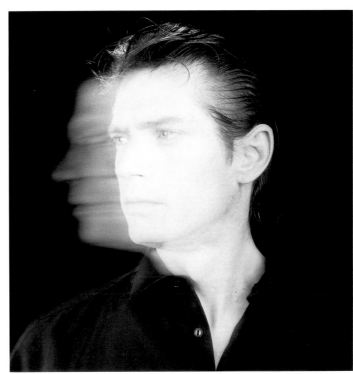

Self-Portrait, 1985

1. A. D. Coleman, *Sight Readings: A Photography Critic's Writings 1968– 1978* (New York: Oxford University Press, 1979), 246–57.
2. *Photographs from the Collection of Robert Mapplethorpe* (New York: Sotheby Parke Bernet Inc., 24 May 1982).
3. Roland Barthes, *La Camera Lucida: Reflections on Photography,* trans. Richard Howard (New York: Hill and Wang, 1981), 42.
4. The photographs were featured in the book *Lady, Lisa Lyon,* by Robert Mapplethorpe, with text by Bruce Chatwin (New York: Viking Press, 1983), and an exhibition the same year at Leo Castelli Gallery, New York.
5. Mapplethorpe differentiates between his commissioned portraits and those he feels are qualified to be produced in editions of ten.
6. The exhibition "The Family of Man," at the Museum of Modern Art, 1955, was a broad survey of physiological, social, and cultural types.
7. Robert Mapplethorpe, *Certain People: A Book of Portraits,* preface by Susan Sontag (Pasadena, California: Twelvetrees Press, 1985), n.p.

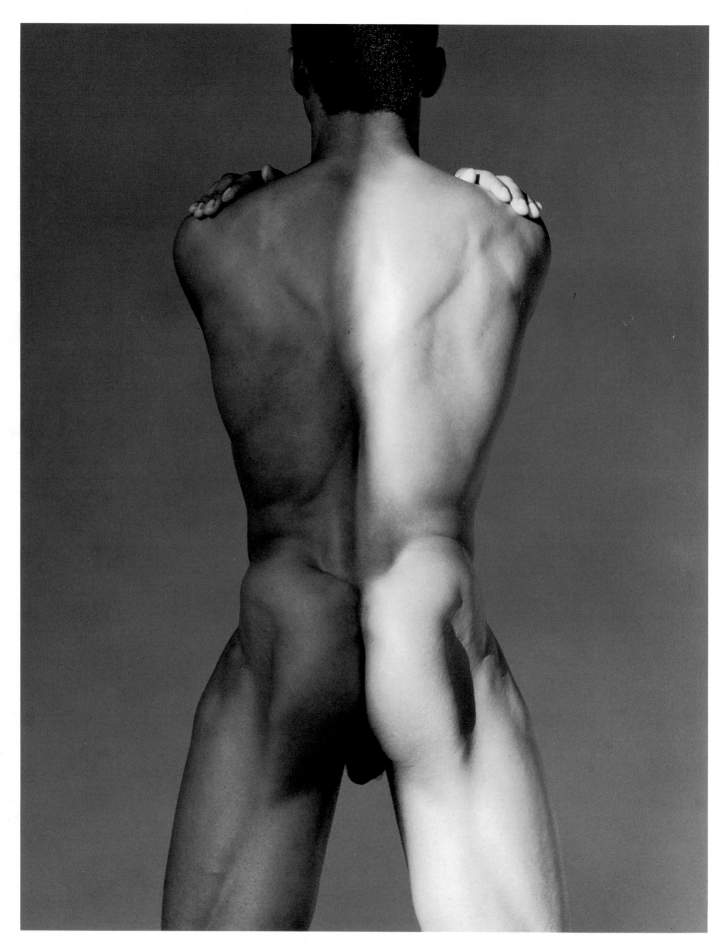

Dan S., 1980

KAY LARSON

ROBERT MAPPLETHORPE

Although it's usually conceded that the creative imagination comes from Eros (the life force), it is generally preferred that the connection be not too directly drawn, at least in polite company. In Freudian terms, the "civilized" mind feels a danger in coming too close to the mental furnace, where the primordial heat of raw desire threatens to scorch the sublimated ego.

The fear is that Eros, the dark force of the id, will begin a guerrilla war against the reality principle, or social contract, by which the ego makes a place for itself in the human community. In order to keep the social disasters of self-gratification at bay, while still getting some id-heat by association, the good citizen turns to the artist, who, it is assumed, will court Eros with enough discretion to convert the process of sublimation into something pleasurable and socially productive.

In the last decade or two—particularly since the sixties—this comfortable social contract has begun to break down. The mental price of self-repression—for women, blacks, gays, Hispanics, or anyone else who courted invisibility for the "good" of the community—has proven to be unacceptably high. The rediscovery of Eros in recent years, therefore, has a political and social dimension. By returning to a primal state of desire, the sublimated self releases itself from bondage and acquires a new, consciously forged identity, perhaps in consort with a group of like-minded people.

Rejecting any pact with polite society, Robert Mapplethorpe has repeatedly stepped over into the domain of the id, ruthlessly recording what he sees there, in pictures that are, by turns, elegant and disturbing. Mapplethorpe is, to my mind, the best classicizing photographer of his generation. He has done something that no one else quite expected him to do: He has proven that classicism and eroticism are not contradictory, that they are two poles of the same experience. Mapplethorpe arrived at this complicated understanding by following his instincts. He began taking pictures at the end of art school, because he needed to incorporate photographs into his collage-installations. Very quickly, he realized that photographs had an autonomous authority—they were a record of "true" experience. Through them he could touch "forbidden" acts and states of consciousness, using the camera as an instrument of provocation—the more provocative because its images were real.

At the end of the seventies, Mapplethorpe made a startling entrance into the art world with his first mature photographs, which became only slightly less unnerving as time went on: bondage and discipline between men, fist-fucking, leather fetishism, body-worship, and extreme states of sexual arousal, including what seemed to be an endless series of tumescent cocks sprouting out of unzipped flies, or erupting from smooth black bellies. Sex was supposed to be a private matter between individuals, but Mapplethorpe saw it as the last frontier of self-liberation and freedom. He took some of his cues from pornography, which, by definition, is photography that steps outside the limits of the socially acceptable. But, mostly, he wanted to look at what interested him in his own life.

There is a kind of sexuality—the kind we think of as modern—that pursues self-interest to its limits, and sublimation be damned. Entering into the homoerotic life near the end of the seventies, Mapplethorpe became its chronicler. The early photographs are not his best, precisely because their content is so blunt and unmodulated; they now seem somewhat more interested in playing havoc with the repressive self than in organizing themselves as images in their own right. They seem to have a secondary agenda. His work took on its greatest power, ironically, when Mapplethorpe recognized his classicism and allowed it to blossom.

Since 1980, Mapplethorpe has produced several series of pictures after which, it seems, photography will never be the same. "Black males" forcibly put forward a formerly taboo subject (for Caucasians, at least)—the sexuality of black men. Lisa Lyon, the feline bodybuilder, presented her ropy muscles and became the dark side of female liberation—the self-involved strong woman, full of erotic confidence and sexual cruelty. In social terms, these images are striped with ambivalence and danger—a factor in their titillating appeal. In photographic terms, they pursue the purest perfection of surface—the beautiful grain of taut skin, the high-tension wiriness of pubic hair. Their classicism is a restatement of sexual fixation, a repeated entry into desire, a merger of the viewer and the subject. Mapplethorpe's pictures are best when

their cool composure seems like a layer of ice over the subliminal heat of the furnace.

Since the early days, Mapplethorpe has also produced portraits and flower studies; neither group seems directly erotic at a casual glance. But his eye is driven to search out just the right decisive and enduring moment. The belief that there is such a moment is one reason Mapplethorpe is a classicist—the opposite, you might say, of a naturalist such as Garry Winogrand, whose pictures plant themselves squarely in the middle of flux. Unlike another paradigm, Edward Weston, Mapplethorpe's classicism is "hot" and sexual—the photographer has openly, rather than covertly, courted his model.

But sex is only one subset of a condition that is, by comparison, vast and entwined in the living nature of existence. When Mapplethorpe discovered desire, he set himself on his way to maturity as an artist. The metallic "skin" of a Mapplethorpe photograph gets its erotic charge through its perfected, obsessive detailing—one's feeling that the surface "breathes" through its silver pores. The gleam of light on a dark body, flowing slowly into the vortex of curly hair in the man's crotch, creates a visceral, gutteral, pleasurable shock. So it is with the perfect flaring arc of an orchid and leaf in a white vase, or the blowsy elegance of a drooping tulip. Flowers and fruit, you recall with a start, are botanical organs of reproduction. A single pear in an empty background swells in slightly awesome fecundity, second cousin (from nature's viewpoint) to the swollen testicles of one of Mapplethorpe's men.

Photography, being a direct record of things in the world, is in a particularly good position to register the forms of desire. It is a process of two-way looking: looking at, and being looked at. Mapplethorpe is a voyeur, and photography is a voyeuristic medium. The act of looking is, typically, the first step in sexual arousal, just as it is in making a photograph. The onlooker looks, and the model, knowing he is being watched, looks back. There is an exchange, a flow of psychic electricity, a promise of pleasure. Running through Mapplethorpe's nude pictures is an undercurrent of eroticism that suggests the photographer has just finished posing a lover. In the case of a more conventional portrait, perhaps of Susan Sontag, or David Hockney with Henry Geldzahler (p. 60), the photographer's involvement is more subtle but no less fixated in the experience. He is alert to the grace and sensuality of gesture: Sontag's wide-eyed sharp gaze, enhanced by the puff of gray hair that rises from her forehead like a stray thought; Lee Krasner, in her last years, as a kind of Everest of female maturity; Philip Glass and Robert Wilson swaying slightly in twin chairs, their hands on knees in unconscious sympathy with each other's presence. The viewer and the viewed—the photographer and his subject—have shared an entanglement, a state of arousal, a mutual experience of subjectivity. It is that sense of subjective presence, of having been witnessed, that lifts Mapplethorpe's pictures beyond simple clarity.

But being a provocateur, he is not averse to running guns into forbidden territory. Mapplethorpe has been accused of racism in using black men as objects of titillation and arousal. Those arguments don't hold up in front of the pictures themselves. As women well know, any object of desire assumes some of the stamp of the person desiring it. That is one of the reasons why the expression of Eros is, potentially, so dangerous for social peace: The desirer absorbs the "other" into his own fantasy, and little matter what the "other" may think. But Mapplethorpe's black men are the first, in my memory of photographic history, to be given full dignity and equal stature as sexual beings—more equal, perhaps, than Mapplethorpe's whites, who tend to be a little nerdy by comparison. The photographer obviously enjoys the flow of light eddying and rippling off polished dark bodies, just as he does the excitement of treading on a taboo (fear of black male potency) dating from the slave trade. By placing his black men on a pedestal, Mapplethorpe seems to be working overtime to violate white clichés. Compare any of these figures to the picture of Andy Warhol, his right shoulder jammed in a doorway, his skin dimpled like putty, his crossed hands covering his crotch like a fig leaf.

Androgyny is the artist's stock-in-trade. To be able to fuse the dualities of existence into art, the artist needs access to extraordinary or forbidden states. Mapplethorpe is drawn to exotic experiences, in part, because their capacity to arouse is still fresh (or else they would not be exotic). In a pair of self-portraits, he poses himself, first, in a leather jacket, macho-style, then nude, with eyeliner and lipstick. This statement has several levels of meaning, but in the main it communicates his willingness to live on both sides of the line. He crosses gender to cultivate yet another state of arousal. He looks for passionate sensual engagement in every experience. And so he delivers to photography an enlarged definition of its usefulness as art. By merging the viewing "I"—in this case, himself—with the otherness of the object—a vase of chrysanthemums, let's say—he converts the object into a subject. That is, he invests this beautiful thing-in-the-world with an erotic charge that transforms it and ennobles it by the passionate entwining of its nature with the artist's. Perhaps all truly creative people do something like this. Eros is passion—life-passion—and arousal, whether sexual or some more general state.

Freud thought that Eros threatened social bonds, but he was also aware that sublimation, if pushed too far, turns in on itself and, in anger and outrage at the repressions it has experienced, discovers the titillations of Thanatos. Then whole societies crash their way toward annihilation, as Germany did twice in this century, singing "Deutschland über Alles" in the trenches. "Eros creates culture in his struggle against the death instinct," writes Herbert Marcuse, in *Eros and Civilization,* adding that "it is the *failure* of Eros, lack of fulfillment in life, which enhances the instinctual value of death." You could argue with Marcuse that Eros fulfilled to an obsessive degree is also a kind of death, or, at least, a

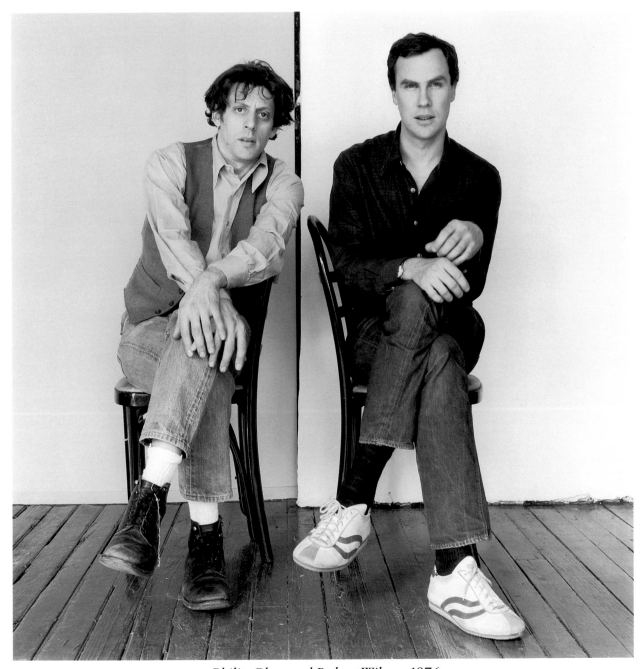

Philip Glass and Robert Wilson, 1976

reification of living desire.

But artists are not required to be moral guides, only illuminators; the roles, indeed, are often opposites. The pulpit is not Mapplethorpe's style; he has none of the moralizing bent, for instance, that characterized the modernist photographers at the beginning of this century. The willingness to live on the edge requires the eagerness to cultivate danger for its own sake, its Eros-enhancing acuity. But Eros made vivid betrays its other face, which is Thanatos. A new morbidity has crept into Mapplethorpe's work of the last year or so. He has begun to photograph skulls, and to pose them with fragments of Classical statuary, which are made to seem, interestingly, like cold white icons of desire. The portent of these pictures is chilling. The Greeks, of course, were the first in Western civilization to erect a culture—a literature, an art, a philosophy—around the homoerotic. The Greek obsession with the perfect body, which is echoed in Mapplethorpe's quest for perfection, is given great weight by the obvious antiquity of the surviving fragments. Homoeroticism, Mapplethorpe suggests, has been around since the beginning of the world. On the other hand, these fragments have been damaged by forces beyond their control; they are not whole, they are broken asunder. Mapplethorpe is too subtle to let such weighty issues interfere with one's experience of the photograph—the damage to these beautiful Classical men is sometimes scarcely visible. But an alert observer knows it is there, and the observation brings with it pain.

It's perplexing—this tie between life and death. Must everyone who lives on the edge necessarily stare over into the abyss? Is all personal liberation a form of social—or worse, private—suicide? Or does the pursuit of personal release offer the only long-term hope for the social health of nations? Those are big questions, and Mapplethorpe is not obliged to answer them. But we can thank him for giving us the art that raises them so brilliantly, and so indulgently.

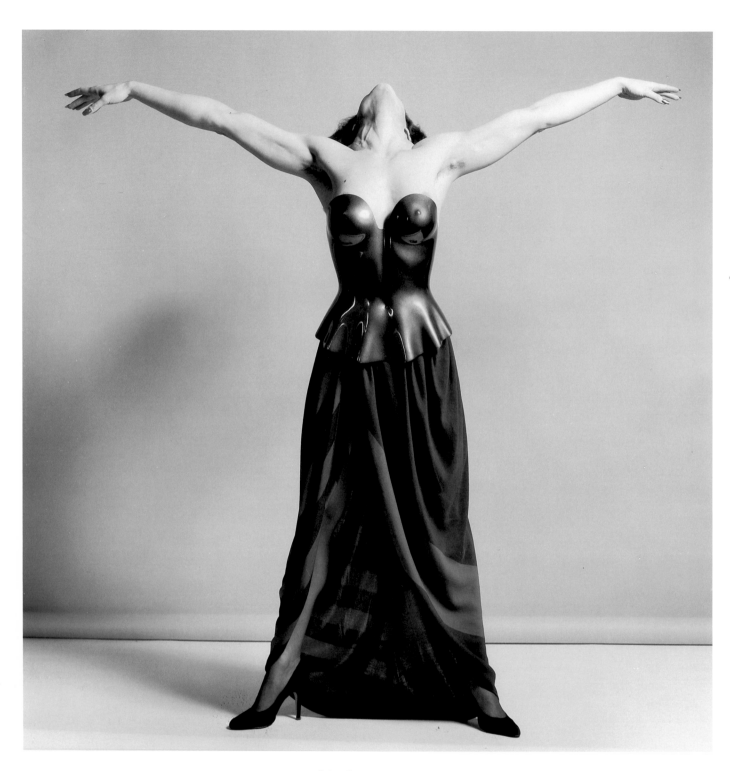

Lisa Lyon, 1982

DAVID JOSELIT

ROBERT MAPPLETHORPE'S POSES

Mapplethorpe confines himself to a world which some people might find emotionally crippled—one of sexual deviation, homosexual sado-masochism and the more extreme varieties of leather sex. . . . "Putting on" the bourgeois audience is now, as it has been from the start, part of Mapplethorpe's persona.[1]

Edward Lucie-Smith

Homophobia is not primarily an instrument for oppressing a sexual minority; it is, rather, a powerful tool for regulating the entire spectrum of male relations.[2]

Craig Owens

The enormous popularity of Robert Mapplethorpe's photographs is often explained (or explained away) as a form of sophisticated naughtiness. His frequent characterization is, in the words of one critic, "the imp of the perverse"[3] is an easy kind of dismissal: It labels him a campy gay man. It is undeniable that Mapplethorpe photographs from a position of sexual marginality, but he occupies a margin that has much to say to the center. As Craig Owens has argued, the social conventions of homosexuality are meant to regulate the behavior of all men, gay and heterosexual alike. It is Mapplethorpe's broader relevance that is typically denied to him—typically obscured by labeling him a subcultural fetishist—by ignoring the hauntingly unstable vision of masculinity *and* femininity his art proposes. Mapplethorpe's complex, compound dramatization of the interplay between sexual aggression and submission—in men and women, heterosexual and homosexual—is clearly evident in the relationship he establishes between his own self-portraits and the photographs of his models.

On the front cover of Mapplethorpe's *Certain People: A Book of Portraits* is a self-portrait. The artist is dressed in a black leather jacket and a dark, soft shirt. His eyes are narrowed, and a cigarette hangs from one corner of his mouth. The back cover has a second self-portrait. This time Mapple-

thorpe's hair is teased into a woman's hairdo; his eyes are open and his lips parted in an unspeakable expression of softness, imploring, and—perhaps—fear. His upper torso is bare and strikingly resembles a woman's breasts. These photographs are repeated, in reversed order, near the center of *Certain People*. As in all of his books, Mapplethorpe's presence, in front of the camera as well as behind it, brackets every representation. The book, full of pictures of the famous, the glamorous, and the notorious, is literally held between two exaggerated conventions superimposed upon the body of the artist: sullen, rough masculinity and vulnerable femininity. It is as though Mapplethorpe tells us that every portrait in the book is some combination, some special alloy, of the two "pure" sexual postures that make up its covers, the two ends of his spectrum.

Like photographers influenced by feminism, who have explored their position as women behind a camera—the very apparatus that has done much to objectify them—Mapplethorpe has courageously created a critical space for the gay male photographer. He has envisioned a world in which masculinity is not stable but a constantly shifting terrain between hyperaggressiveness and submission—the space of Jean Genet's *Querelle*. The jump from Mapplethorpe as a cigarette-smoking, dangerous-looking guy to a disarmingly

seductive "woman" (or the "woman" in a man) creates an anxiety that is prevalent not only among homosexuals. As Eve Kosofsky Sedgwick has written in *Between Men,* her study of male bonding in nineteenth-century literature, "For a man to be a man's man is separated only by an invisible, carefully blurred, always-already-crossed line from being 'interested in men.'"[4] Mapplethorpe's two self-portraits, which bracket all of the figures represented in *Certain People,* embody this anxiety of crossing boundaries—not only the apparently simple gender boundary between man and woman but also the line that exists within *both* men and women, between aggression and submission.

In *Lady, Lisa Lyon,* a book of photographs of the bodybuilder Lisa Lyon, the interplay between phallic drive and passiveness—or guilt—is enacted not on the body of the male photographer but the body of a woman. In *Lady,* Mapplethorpe organizes sequences of images with a filmmaker's narrative precision. Explosions of implied or potential violence alternate with calm, classical images; kinky costumes and suggestive poses are succeeded by high-fashion shots such as Lyon standing with her head thrown back, in which she poses in an Issey Miyake dress (p. 18). Lyon's persona (it is hard to think of this book as anything but a work of fiction), like Mapplethorpe's double self-portrait in *Certain People,* is disturbingly bifurcated: She goes from "good" to "bad," passing through various states of potential goodness and badness on the way. The frontispiece of *Lady* holds a double portrait of Lyon and Mapplethorpe, both in sunglasses with arms crossed, in the attitude of a standoffish, stylish young couple. The pronounced heterosexuality of this photographic epigraph is intensified by their double dedications: "To my husband," for Lyon, and "To Patti Smith," for Mapplethorpe. Beyond this first impression, the picture takes

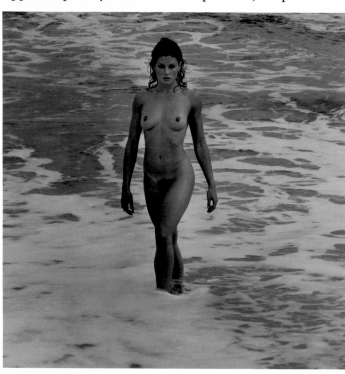

Lisa Lyon, 1980

on a sinister edge. Although one assumes that this is the one representation in the book that captures the "real" Lyon and the "real" Mapplethorpe, their dark sunglasses establish an unbridgeable distance between them and us: With their eyes obscured, they begin to look strangely alike; they become not a couple but twins.

It is, therefore, always with the shadow of Mapplethorpe beside her (and, of course, literally in front of her) that Lyon runs through her transformations. A sequence of pictures in the first third of the book is typical of its dynamic. Beginning with several nude and seminude photographs in the landscape —including one in which she is reclining on rocks (p. 54), where Lyon's pose is reminiscent of Edward Weston's nudes, and one memorable picture where she stands on the beach a little way into the water, like a freshly bathed Eve (p. 20)— Mapplethorpe establishes a kind of paean to the female body, informed by the history of twentieth-century photography. This seductive vision of idealized femininity, which is intercut in the series by further (seemingly masculine) idealizations of Lyon photographed in stock bodybuilding attitudes, is shattered by the eruption of a two-page spread of Lyon girded in black bikini and scuba gear, startlingly reminiscent of costumes of gay-leather subcultures. The fantasy is further developed in two subsequent photographs in which Lyon wields a knife—first, in her scuba gear, and then silhouetted against a disc of light. This sinister interlude, which transforms Lyon from a powerful beauty to a hieroglyph of aggression, is "resolved," almost denied, by the next picture, in which she is represented as an apparently affluent woman standing under the knifelike snout of a stuffed swordfish.

The well-paced narrative sequence of *Lady* is characterized by such dips into violent or aggressive fantasy. But the message remains clear that the pleasure of these fantasies is illicit, that they are purchased with guilt. Nothing in the book expresses this so poignantly as the last double-page spread of photographs. The image on the left shows Lyon nude, her head visible but her face obscured by her hair, holding a pistol in her black-gloved right hand, pointed out of the picture. In the opposite image she points the gun at her own heart. Her aggression, her violence, her identification with the phallic, no longer directed outward, is channeled into self-destruction. In the end, the chilling revelation of *Lady* is the fear that sexual assertiveness transforms one into a killer. Although this is the fantasy of Lyon's "character," it is also, by implication, a fascination of Mapplethorpe's. Together, they create a persona that thrills in danger, and then repents.

In the context of gay fantasy, the romance of the killer— who is also capable of submission (who will let himself be "shot")—once again recalls Genet's iconic characterization of Querelle, who is both a murderer and a passive lover. Mapplethorpe's self-portrait in a black leather jacket over a tuxedo shirt and white tie could be the image of a gentleman Querelle. He holds a machine gun, finger on the trigger, but he imagines himself as a killer with an unexpected expression: His eyes are more arresting than the gun barrel, and unlike

t, they shoot straight out. Their message is indecipherable and mesmerizing: Paradoxically, with gun in hand, these eyes seem capable of love.

In *Black Book,* the drama of assertiveness and submission, which was superimposed on Lisa Lyon in *Lady,* is explored through the bodies of black men. Mapplethorpe's small, enigmatic self-portrait comes at the very end of this book, not on the cover or frontispiece, as in *Certain People* and *Lady.* Dressed in black tie (a different kind of black from the rest of the book) and looking very white, his head is turned away, but his eyes are directed out, almost in, to the book. Mapplethorpe therefore positions himself behind the extraordinary phallic display that makes up his work. Like his own, these phalluses—whether they are literal penises, clenched fists, or shaved heads—are in front of him. As in the extraordinary *Man in Polyester Suit* (p. 69), where a figure dressed in a three-piece suit, his face obscured, allows his large, semierect penis to hang from an open fly, the sequencing of *Black Book* implies a violent eruption/erection of sexuality in a setting of middle-class composure. The suggestion of autobiography is compounded by Mapplethorpe's typical intelligence in creating titles with multiple meanings: Is this *Black Book* his little black book?

The *Black Book* is not so much a collection of portraits as a series of conventional images, some specifically related to stereotypes of black men. Mapplethorpe has photographed his models as classical nudes, jungle inhabitants, athletes, allegorical figures, soldiers, and tough guys. Although these types are easily readable—like the ones Lisa Lyon rehearses—they are endowed by Mapplethorpe with enormous power: their physical presence is immediate and unavoidable. Not only do most of his models have well-developed physiques but many unself-consciously display large, semierect penises. The effect of their exposed sex is not truly pornographic, or even erotic; Mapplethorpe allows no sense of sexual play or arousal to interfere with our opportunity to *look.* If, in any sense, these pictures are portraits, they are portraits of something that usually remains invisible: the phallus.

With few exceptions, these exaggeratedly phallic men look out at the viewer—and at Mapplethorpe—with an expression of sullen threat, of suppressed violence. Far from inviting intimacy, they hold it at bay. In one picture, a nude Dennis Speight holds six calla lilies in the conventional pose of the Annunciation (p. 45). In spite of his apparent symbolic function—as one who *announces*—Speight seems intent on withholding communication instead of sharing it. His mouth set, his eyes are stern; he grips the lilies in what amounts to a double fist. Speight is uneasy in his role as an allegorical figure: He seems about to explode. In other pictures, Mapplethorpe makes such an implication of hostility explicit. In two pictures of Jimmy Freeman and Charles Bowman, on facing pages near the end of the book, the men, half undressed, look ready to assault. Even an apparently straightforward portrait, such as the picture of Roedel Middleton's head in three-quarter view, carries a suggestion of threat.

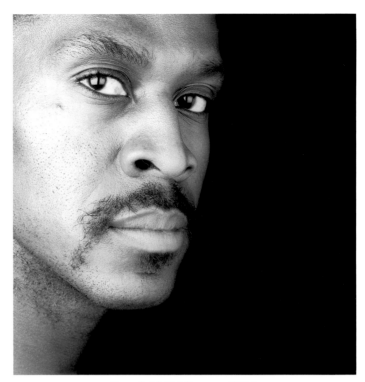

Roedel Middleton, 1986

In the *Black Book,* Mapplethorpe has combined power with rage. His subjects look angry, but whether it is an anger related to their social oppression as black men or whether their fury is a metaphorical response to suspended or muffled sexual aggression constructed by the photographer—whose anxiety-ridden, dandyish self-portrait floats behind them—remains an open question. In either case, in this sequence, as in his photographs of celebrities or Lisa Lyon, Mapplethorpe has established conventional postures in order to explore a terrain of sexual anxiety.

To look only at Mapplethorpe's exquisitely crafted single images and not at the shifting narratives he establishes, both in his books and exhibitions, is to overlook a great portion of his accomplishment. In his photography, the paradox of *posing* for the camera—its inherent combination of aggression and submission—is developed from a private anxiety to an iconic or universal one. The message that Mapplethorpe delivers is that the experience of any masculine or feminine identity is the sensation of an unstable, constantly readjusted succession of poses. In his work, the crossing of boundaries between aggression—or phallic drive—and submission is not simplistically developed as an opposition between masculinity and femininity, it is experienced as a drama that takes place within the entire range of sexual identities—in man and woman, and in homosexual and heterosexual alike.

1. Edward Lucie-Smith, "Robert Mapplethorpe," *Art and Artists* (November 1983), 16.
2. Craig Owens, "Outlaws: Gay Men in Feminism," in *Men in Feminism,* edited by Alice Jardine and Paul Smith (New York and London: Methuen, 1987), 221.
3. Christine Tamblyn, "Poses and Positions," *Artweek* (27 June 1987).
4. Owens, "Outlaws," 231, part of a quote from Sedgwick that Owens uses in his discussion of the relationship between homophobia and feminism.

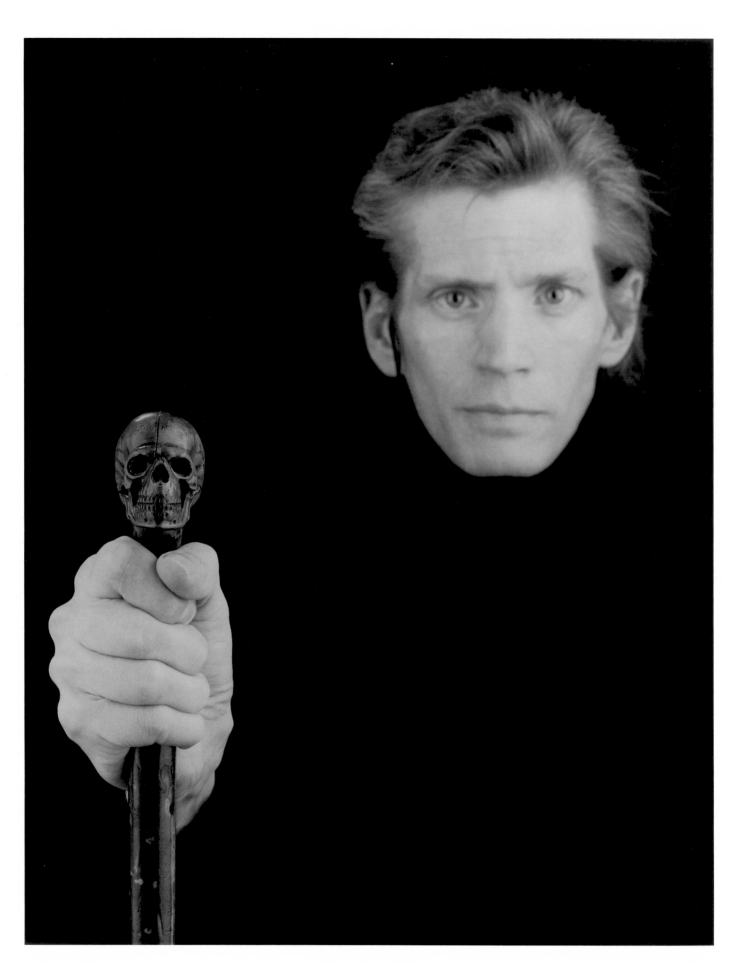

Self-Portrait, 1988

JANET KARDON

ROBERT MAPPLETHORPE INTERVIEW

Janet Kardon interviewed Robert Mapplethorpe at his home on West 23rd Street, in New York, on July 2 and August 13, 1987. Mapplethorpe's home contains remarkable collections of 1950s glass, mission furniture, and nineteenth-century photographs as well as his own works. The conversations took place around a coffee table designed by Mapplethorpe.

Janet Kardon: When you and Patti Smith were together in the early 1970s, you both spent a lot of time at Max's Kansas City.

Robert Mapplethorpe: I finished art school in 1970, arrived in Manhattan with Patti Smith, and checked into the Chelsea Hotel for a year or year and a half. We had the smallest room in the hotel, but it was what we could afford; and we had to pretend there was only one of us because it was too small for two people. We went to Max's Kansas City almost every night. We had lots of scarves and cheap clothes, and one of the more exciting things to do was dress up. We'd sit in the back room at Max's and nobody would talk to us. New York is a very closed city; it takes a while before you can crack any of the people. Eventually, somebody came over, and we got to know one person, then another person, and it just snowballed into us being accepted. Patti was doing readings at the time at St. Mark's, and I was doing collages, starting to take photographs, and also doing jewelry. I worked in semiprecious stones and things chased in gold. Someone wanted to back me as a jewelry designer, but I backed out. I didn't think it was important enough.

JK: Who was there?

RM: All kinds of people, but it was usually musicians, writers, trendy models, and some photographers—people who were becoming something that they never became. There were drag queens and people who were in Warhol movies, but were never really quite talented enough to do anything else.

JK: You were making collages and fetish objects. Where did you go to art school?

RM: I went to Pratt, where I did collages. I was also making photographic objects with material from pornographic magazines. At some point, I picked up a camera and started taking erotic pictures—so that I would have the right raw material and it would be more mine, instead of using other people's pictures. That was why I went into photography. It wasn't to take a pure photographic image, it was just to be able to work with more images.

JK: When you met Sam Wagstaff, were you using a camera?

RM: Yes. I met John McKendry a few years before that, and got more involved with photography through him; he was the curator of prints, drawings, and photographs at the Metropolitan Museum. Through him, I was exposed to photography in a way I had never been before, and I started to look at the photograph as a form in itself.

JK: Whose photographs did you look at?

RM: John did a show of the photosecessionists that was important to me. I think John bought me my first Polaroid camera. Even the earliest Polaroids I took have the same sensibility as the pictures I take now. Right from the beginning, before I knew much about photography, I had the same eyes. When I first started taking pictures, the vision was there.

JK: That's what I find so remarkable about everything you've done—in any medium and any subject. Your work is very consistent, disciplined, and ordered.

RM: Well, unbeknownst to myself, I became a photographer. I never really wanted to be one in art school; it wasn't a high enough art form at that point. But then I realized that all kinds of things can be done within the context of photography, and it was also the perfect medium, or so it seemed, for the seventies and eighties, when everything was fast. If I were to make something that took weeks to do, I'd lose my enthusiasm. It would become an act of labor and the love would be gone. With photography, you zero in; you put a lot of energy into short periods, short moments, and then you go on to the next thing. It seems to allow you to function in a very contemporary way and still produce the material. It also allowed me to travel and still be productive. It just seemed to make a lot of sense.

JK: What about Sam Wagstaff? What do you think he brought

you, and what did you bring to him?

RM: We had this great relationship; we exchanged information and aesthetics, and he opened up certain areas.

JK: Was he interested in photography before he met you?

RM: No, not really. And I was just barely interested myself. But at some point, we both became involved.

JK: And so you formed a collection together?

RM: Initially, we both looked at everything, and then, at some point, I started doing my own work. He was buying things like a madman. He saw beauty on every level, from the amateur all the way up—in postcards and everything. We were both living on Bond Street. On his way home, he'd stop by with shopping bags full of great photographs, and some not so great. He'd come over and want me to be his audience, and I was for awhile, until I finally said, "Sam, I'm taking my own pictures. I'll never take another picture if I look at these things." Anyone who is so visually oriented is going to reach a point of saturation. I did learn a lot, and it was a great experience to be able to handle the pictures. Often, you see pictures under glass, and it's not the same.

JK: It strikes me that your sitters appear to be very well prepared, even staged. It's never a casual shot, but then, you call photography fast. How long does a photo session take?

RM: Sometimes I need to know the people really well before I can get pictures, so that in itself is time consuming; but the actual portrait is done in two hours or so.

JK: So it's about getting ready. Does someone else finish? You don't do your own developing, do you?

RM: No, but I have to get my head in the right frame of mind to look at contacts and figure out which exactly is the right picture, and nobody can do that but me.

JK: How many will you shoot to get the right one?

RM: Usually five or six rolls. When I do commercial work, and I'm being paid a lot of money, I may stick extra film in, which isn't to say that I don't get to know the sitter. I may do ten for the commissions, because I think people want more. Part of being a photographer is knowing when the subject is exhausted. I've found that other photographers are not very sensitive to that; they go on, and they overdo it. When I would be bored, they're still taking pictures. You put out a certain energy for photographs, and photographers often are not that sensitive to people. I think that pictures taken at the moment the subject feels most comfortable are the best.

JK: I don't quite understand why, but if somebody is born Catholic and they no longer practice, they still say, "I'm a lapsed Catholic." Christian objects and imagery surround you in your home, and you've actually made crosses. How else does that feed into the work? Or do you think it does at all?

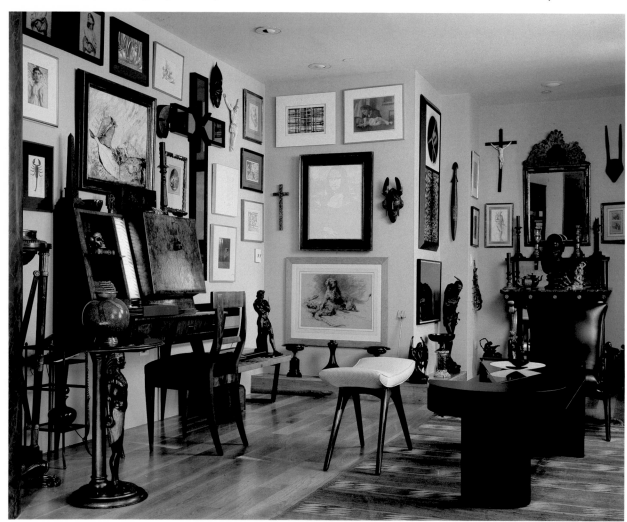

Robert Mapplethorpe apartment, 1987

RM: I think that it does in that being Catholic is manifest in a certain symmetry and approach. I like the form of a cross, I like its proportions. I arrange things in a Catholic way. But I think it's more subconscious at this point.

JK: Is it similar to the precise placement of ceremonial objects on an altarpiece?

RM: Yes. The early fetish things were kinds of altarpieces, but you don't say you're going to do an altarpiece.

Film is an area that I would like to be more involved in. I've talked to actors and directors, and I'm interested in doing a film with a good budget, but it doesn't have to be a long film. Up to now, the two films I've done are really more experimental and less than perfect, and I find that frustrating. I didn't have the money for the right hair people or stylists. The one about Patti [Smith] is more interesting because it's definitely an underground film, and it was done with the idea of possibly doing a rough video. Every time I see something in it that isn't perfect, I think it is an art film, but you shouldn't hide under that.

JK: You've done stage sets, too?

RM: I did a ballet with Lucinda Childs. It was really successful, but it also suffered from a certain lack of perfection because the budget was small. Her work is very minimal; I added passion, in terms of color and lighting. She has real talent, but I think I made the work more palatable to more people, although I was criticized for overpowering what Lucinda does.

JK: Did she like it?

RM: I think she was really happy with it. There were photographs flashed onto the backdrop.

JK: Your photographs?

RM: Yes. Pictures of Lucinda Childs's hands and flowers, done in heavy gels.

JK: So many of your photographs are frontal, similar to a trecento Madonna painting. You often use the word "perfection," and there is a kind of perfection about the work—a purity. It's often symmetrical, and in this way it relates to the crucifix.

RM: The work is very direct. I try not to have anything in the picture that is questionable. I don't want anything to come in at an angle that isn't supposed to come in at an angle.

JK: What do you mean?

RM: I think my pictures are the opposite of Garry Winogrand's.

JK: Would you ever take a snapshot?

RM: I have, but it's not what I do best. I photographed a party once in the Caribbean. I hated it. You try to get something out of it through a camera, but at a party I want to be at a party.

I just did a shoot in Louisiana, in the bayou. I don't want to be a wildlife photographer, but I wanted to do it once and see what it was about. I went to the Bronx Zoo yesterday. The same magazine wants me to do the zoo, and that's going to be my next thing. I throw these ideas out and then I'm stuck with them. You've got bars to deal with, and I guess you could certainly get inside, but . . .

JK: Be careful.

RM: I won't go into the polar bear cage.

JK: Thank you.

RM: But it's a lot of work. I need new equipment, because you can't get close enough in certain cases. Then I want to go to a game preserve and photograph, but that's going to be even harder. A lot of things sound better than they are. Your whole life in retrospect may well seem great, but the reality of it is different.

You know, I sold my collection. I had a small collection.

JK: Yes. Your collection and your work evidence the same vision. There's a purity to the flowers that makes them somewhat untouchable, removed, again Madonnalike, while the S & M pictures and the other sex pictures go to another extreme. Do you see them as different?

RM: No, I don't really think so. I think that the flowers have a certain—

JK: Are sexy?

RM: Not sexy, but weird. I don't want to use the word "weird," but they don't look like anyone else's flowers. They have a certain archness to them, a certain edge that flowers generally do not have.

JK: Do you think they're threatening?

RM: That's not the exact word. But they're not fun flowers.

JK: No, they're not.

RM: I don't know how to describe them, but I don't think they're very different from body parts. Maybe I experiment a little more with flowers and inanimate objects because you don't have to worry about the subject being sensitive or worry about the personality. I don't think I see differently just because the subject changes. I couldn't have taken certain of the early sex pictures if I wasn't sensitive to what could be in a given situation. I had to be flexible to the situations, and some of them are more formal and controlled because I had the opportunity to do that. With flowers, I can always juggle things around. It can take two hours to just set up the lights.

JK: Do you know what you want before you set up?

RM: No. If I click when I'm doing a day of flowers, I can get three or four pictures in one day.

JK: One day you'll work on flowers, and on another with models?

RM: I make an effort to. I get flowers sent to me, and I have to shoot them that day. Sometimes, I bring in a friend who's an art director to make it easier. When I've exhibited pictures, particularly at Robert Miller Gallery, I've tried to juxtapose a flower, then a picture of a cock, then a portrait, so that you could see they were the same. I just would like people to be able to get the real meaning. I did a picture of a guy with his finger up a cock. I think that for what it is, it's a perfect picture, because the hand gestures are beautiful. I know most people couldn't see the hand gestures, but compositionally I think it works. I think the hand gesture is beautiful. What it happens to be doing, it happens to be doing, but that's an aside.

JK: Let's look at it another way. You bestow elegance on a

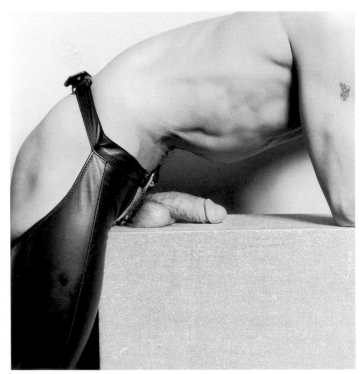

Mark Stevens (Mr. 10½), 1976

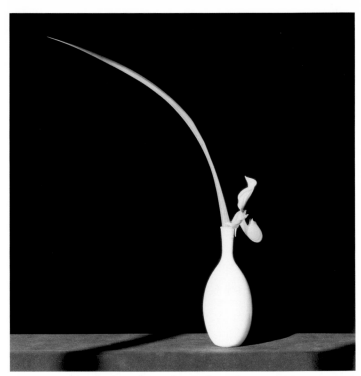

Orchid and Leaf in White Vase, 1982

subject one would never consider as elegant—in the photographs of the cocks, for example. One might not say a cock was elegant.

RM: I might.

JK: All right, one might. In the heat of ardor, you might think, "That's an elegant cock." Normally, it's not a subject you would consider elegant. But you think of flowers as possessing an elegance, or refinement, and I think you treat the flowers like the cocks and the cocks like the flowers.

RM: Yes, I think they're the same. A cock is more problematic when you're photographing, especially if you want it erect. You can't juggle the lights as much, and it's hard to refine the photograph quite as much as you'd like, but I attempt to make just as refined a photograph as of one of the flowers.

JK: Picasso continually returned to an artist-and-model motif. They are very much like self-portraits, almost diaries, because his depiction of the artist changed as he aged, and the model always resembled whomever he was in love with at the time. Are you involved in a similar way with your subjects?

RM: Not really, because I'm not involved with some of the subjects I've photographed over and over again, such as Ken Moody. I can fall in love with the subject and not be personally involved. And I can photograph somebody that I don't like at all. There's one person in particular I photographed any number of times; as a person, he's horrible, but I couldn't take a bad picture of him. There was a sympathy in the studio, but outside I couldn't talk to him. He was disgusting. I might have flowers around and not bother to take a picture of them; and I like vases, but I like them without flowers. If I put them together, I love taking pictures of them, but it doesn't mean I love flowers. When you're working with a subject, I think you have to love it, but you don't have to love it afterward. I can do a commissioned portrait of somebody who's not my kind of person at all.

JK: So you have taken a picture of somebody you really didn't like?

RM: Yes, I have, but I loved them when I was taking the picture. I think you have to unless you have a different approach to photography. I think you have to love when you're taking pictures.

JK: Or be fascinated. Diane Arbus would be fascinated.

RM: I don't know; I think she probably had enough passion. In order to take your pictures, you have to like what you're doing at that time.

JK: I've been thinking of some earlier photographers, such as Man Ray or August Sander, in relation to your work.

RM: I don't think I was influenced by what I've seen. From the early Polaroids, I had a style, a way of seeing. As time went on, I learned the history. You may be subconsciously influenced by what you've seen, and I've seen a lot.

JK: How about someone like Edward Weston?

RM: Too dry for me.

JK: Lartique?

RM: I don't like the quality of his later prints. You present photographs on a gallery wall and try to make them hold the wall; sometimes I think photographs are often better viewed held in the hand or in books. You don't see all the sloppy handwork and retouching when fashion photographs are seen in a magazine. Cecil Beaton's photographs are seen better in reproduction. I met him a couple of times. He wanted desperately to be viewed as an artist. We went to look at his photographs and all he wanted to show us was his sketches. And then someone like Man Ray, whose photographs I admire, didn't want to be seen as a photographer. When I first did commercial work, I worried all night about it, because I was getting paid, and I had to please all these people. I think Warhol is important.

JK: I do, too, and I think he's still undervalued.

RM: No, he didn't have the respect that he deserved. I think you could go through lots of pictures of mine and say, "Well, that's like this artist and this one is like that artist." But I would like to think that the influences are not that strong.

JK: I think your photographs are more about sculpture than painting.

RM: If I had been born one hundred or two hundred years ago, I might have been a sculptor, but photography is a very quick way to see, to make sculpture. Lisa Lyon reminded me of Michelangelo's subjects, because he did muscular women. The best pictures have something I've never consciously been aware of before.

JK: Do some things come upon you as a surprise?

RM: Yes, sometimes I look at an image and I think that everything's coming together. I know when I'm taking good pictures. I've always taken great pictures of Patti Smith.

JK: Is it because of the chemistry between you?

RM: It's that and something else. It's like taking drugs; you're at an abstract place, and it's perfect.

JK: I thought the installation of your one-person show at Robert Miller was brilliant. Was it deliberate that although *Mercury* and *Lucy Ferry* [p.104, 105] were sited on facing walls, both subjects were staring out of the window at the same distant perspective point?

RM: When you put together an exhibition, you arrange things according to how they visually work on the wall. They may also work quite well across from one another.

JK: But they were staring at the same place in the distance, somewhere beyond the window.

RM: But I didn't know that when I was taking the pictures.

JK: Did you know that when you were installing them?

RM: Yes.

JK: I think the entire body of your work is so carefully and precisely controlled. The same sense of precision and clarity in the Robert Miller Gallery installation is evident in the way you display your own art and objets d'art collection. Recently, you worked with *Harper's* models, who routinely "present" themselves, but when you're working with people who are not accustomed to this, how do you make them present themselves? Or is that something you even think about?

RM: You're thinking about making the subject feel comfortable. Is that what you mean?

JK: No, not really comfortable. I mean that certain moment when a face lights up or an actor turns on. There is something artificial about it, but it is also perfect.

RM: In order to get people to that point, they have to be comfortable.

JK: Let's talk about getting people comfortable. You do that very well. I think you have special skills with people.

RM: Other photographers approach the whole thing differently, but as a photographer you're collaborating with the subject. You're doing something together, and if you can make the person feel like that, that's when it works. I'm only half the act of taking pictures, if we're talking about portraiture, so it's a matter of having somebody just feel right about themselves and about how they're relating to you. Then you can get a magic moment out of them. In portraits, taking the actual picture is only half of it; developing your personality to a point where you can deal with all kinds of people—that's the other half. I think the greatest portrait photographer of all time was Nadar, and he was probably one of the most interesting, if not the most interesting, photographers ever. You can tell by the way the subjects give themselves to the camera that they're not sitting in the company of anyone other than their equal. They're not just doing something for a picture; they respect the photographer. Of course, in Nadar's time, it was often the first time they were being photographed, so that the whole experience was not just another photo session, which unfortunately is the case today, because everybody is so oversaturated with photography. It's not a secret, but I want to get more out of a person than someone else might.

JK: It seems to me you approach your subjects in a much friendlier way than someone like Diane Arbus, who looks for the strangeness in people. You really want to find the very best in your subjects.

RM: That's the way I see it. I'm left with a diary of photographs I've taken over the years. I don't write, so that's it. I would rather go through the pages of my life, so to speak, and see people the way I would like to have seen them. Some of them are lies, some of them are nasty people, but they don't look nasty in the picture. But I would rather have a group of people that I wouldn't mind meeting, if I had never met them, to look back on as opposed to a collection of people I didn't like. That's my approach. Some people who've written about me have commented on nasty aspects in my photographs—that everybody's scowling. I've read very negative pieces written about the kinds of people I photograph and the look I get out of people, but I don't see it that way at all.

JK: In your own way, you make everyone beautiful.

RM: Sometimes they're tough, but they're not people you would never care to know.

JK: Obviously, the camera has a great ability to lie, but it's more difficult to make the camera lie if you have no backdrop, and if you have isolated a single subject to put in front of the camera.

RM: First of all, there's no voice, and the voice is important. If somebody doesn't have a nice voice or a nice manner, it is eliminated, and if they have a gesture that you don't like, you just don't photograph that gesture—or I don't. So, you can still lie.

JK: Do you like that about the camera?

RM: Yes. It's seen as a lie, but it's my truth, so it's not a lie to me. In the end, it's what I remember, and I would rather have pleasant memories.

JK: That's very well put. I know you're dealing with sexuality, but it seems to me to be a kind of pristine, almost rarified impression of the sexual experience. Sex is also messy and unpredictable and more instinctive than the carefully con-

trolled vista that you present.

RM: Have you ever seen the X, Y, and Z portfolios? X portfolio is thirteen sex pictures, Y is flowers, and Z is blacks. The earliest of the S & M pictures are in the X portfolio. They're small, they're 8 by 10s mounted to cards, and they come in a box. It may be interesting to have a wall in the exhibition with three rows of X, Y, and Z—but three rows all in one mass. It will cover a spectrum, certainly of the sex stuff, which might be a good way to do it. When they're hung like that, it's like a block.

JK: That might make the point you always allude to: that you don't see any differences in your subjects. You don't think of one genre as being sexy and one as being pure. Why do you think they're all the same?

RM: The same is that I'm seeing them; it's my eyes that are photographing them. Whether I look at a piece of bread or I look at a flower or I look at you, I'm not seeing any differently.

JK: You said that you didn't write, that your photographs are your diaries. Do you read?

RM: On rare occasions. I read the Post, but, no, I'm not a reader.

JK: Do you listen to music?

RM: Quite a bit. I just try to keep in touch with what's going on.

JK: With new popular music?

RM: Yes, I pay attention. I listen to it. But I'm not a music freak either. I just take pictures.

JK: I don't think of your work as simply part of a pure photography continuum, where many photographers come out of a literary background. They were English lit. majors, English professors, or writers. Their photographs are often narratives or have a political point of view.

RM: I'm not typical. Thank God for that. Mine are just pure visual treats. (Laughter)

JK: Are you aware of any stylistic or conceptual changes in your work since the early seventies? I look at your work and I feel it's seamless; it has a consistent vision. Are there stylistic or conceptual changes I'm not aware of?

RM: Not really. I think the work moves toward a kind of perfection. Over the years, the lighting has probably been controlled more, the precision is greater, but basically the vision is the same. It's just a matter of refining.

JK: All the subjects were there from the beginning. You didn't suddenly decide to do portraits or flowers?

RM: No, they're all the same. I haven't gone anywhere. (Laughter)

JK: You speak about perfection. Nirvana is a kind of philosophic perfection.

RM: Perfection means you don't question anything about the photograph. There are certain pictures I've taken in which you really can't move that leaf or that hand. It's where it should be, and you can't say it could have been there. There's nothing to question as in a great painting. I often have trouble with contemporary art because I find it's not perfect. It doesn't have to be anatomically correct to be perfect either. A Picasso

portrait is perfect. It's just not questionable. In the best of my pictures, there's nothing to question—it's just there. And that's what I try to do.

JK: I think you have to work with a camera for what you're seeking.

RM: It would be too academic to paint today. It would take me a year to make a painting.

JK: You spoke about a camera being fast, that one second would change something.

RM: The camera's a perfect medium for me.

JK: In the Anne Horton interview, Sam Wagstaff aligned your work with pop art.

RM: I come out of that. I was in art school when pop art was the rage. I was in academic art training at the time, and I wasn't following the trends; I was just doing my thing. But since I come out of that time, the Warhol influence is there.

JK: Warhol in terms of subject matter?

RM: Not in terms of subject. I don't think I would have done what I've done if Warhol had not appeared as an influence at some time.

JK: In terms of personality?

RM: No, I think I was subconsciously influenced by Warhol. I couldn't have not been—because I think he's the most important pop artist—but I'm not sure how.

JK: Do you like his photographs?

RM: No, I don't even think he liked them.

JK: I might have related your work to Lichtenstein's, which is very classical, hard-edged, pure, and clean. Warhol's a little more accidental.

RM: I'm not talking so much about the product as the statement—I mean the fact that Warhol says "anything can be art," and then I can make pornography art. I think Duchamp is probably more important though. Certainly, Warhol comes from Duchamp, which is the opening up of a way of thinking, of possibilities.

JK: It's very intellectual, and it's not necessarily emotional or painterly, or expressionistic. It's in the other direction. Would you describe the black studies as being political, social, or intimate?

RM: They're probably all of that, but that's not their intent, that's not why they were taken.

JK: Why were they taken?

RM: They were taken because I hadn't seen pictures like that before. That's why one makes what one makes, because you want to see something you haven't seen before; it was a subject that nobody had used because it was loaded. It's no different than the pictures I did of sexuality; I think it's the same kind of work. I know somebody in New Orleans who photographs black men, too, but nobody's done it the way I do it.

JK: Do you put anything on their bodies?

RM: No. Sometimes they want to, but that's not what I like to do. I don't like all that—you mean, oil and stuff like that?

JK: Yes.

RM: No. They sometimes insist on it, but I don't like it.

JK: They do?

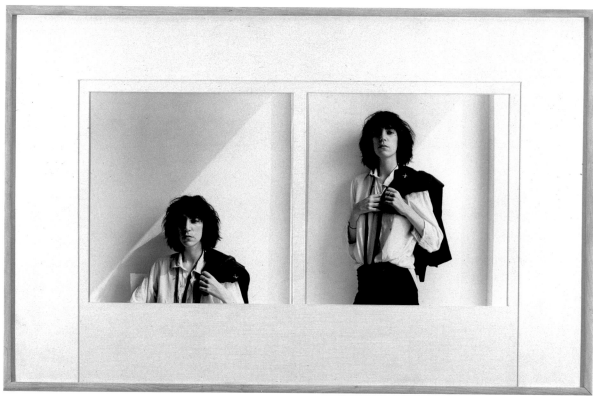

Patti Smith, 1975

RM: Bodybuilders put oil on their bodies. They think it defines the muscles better, but I think it's much more interesting when a body doesn't have oil.

JK: The skin in your work has remarkable texture.

RM: Yes, but I don't have any set formula. If somebody feels more comfortable putting oil on their body, I'm not going to stop them, but I try to dissuade them.

JK: Did Lisa Lyon?

RM: In certain pictures. But then, we were doing a whole book.

JK: In some of them I believe she had graphite on her body.

RM: Yes. In that case, we were trying to do every trick we could to have a book that worked, so I had no objection to any experimentation.

JK: Do you do black figures because white people would be somewhat shocked by looking at nude black bodies, or because black males might be considered sexual objects?

RM: Why did I? I don't know; I was attracted visually. That's the only reason I photographed them. But once I started, I realized there's a whole gap of visual things. There have been great photographs of naked black men in the history of photography, but they are very rare. Some of my favorite pictures happen to be the pictures of black men. I'm over that phase, I think; I'm not photographing anything naked these days. That isn't to say I won't again, but I haven't been concentrating on bodies recently.

JK: Are you doing more portraits?

RM: Yes, and fashion work. I'm interested in experiencing the commercial photography world. I think it's at least as interesting. Once I've done something, I feel that I've done it. I get to a point where it's repetitive, another beautiful body. Also, you start saying, that one's not as good as the one I did two years ago, or I've already had the perfect people to photograph. I just recently tried to photograph a black man. He had a really good body, but I've shot better ones, so I started thinking in the middle of the shoot, Why am I doing this? I've already done it.

JK: Do you think there are things that haven't been said about your work that you would like people to think about?

RM: No, I don't really think like that. I guess I'd like the work to be seen more in the context of all mediums of art and not just photography. I don't like that isolation.

JK: I think of your work as more like sculpture than painting. Your images appear as if they might have been chiseled. A stillness surrounds each of them, as if each image were a piece of sculpture with its own space around it.

RM: It is sort of a lazy man's approach to sculpture, but it would be totally ridiculous to sculpt in marble today.

JK: If it weren't ridiculous, would you like to?

RM: I couldn't sit still long enough to do it. The era is over for that. Maybe if it was two hundred years ago, but it just doesn't make any sense to sit still long enough to do an oil painting on canvas. That's why photography is so good. You can concentrate for a short period of time and really be involved, and then go on to something else and not be labored.

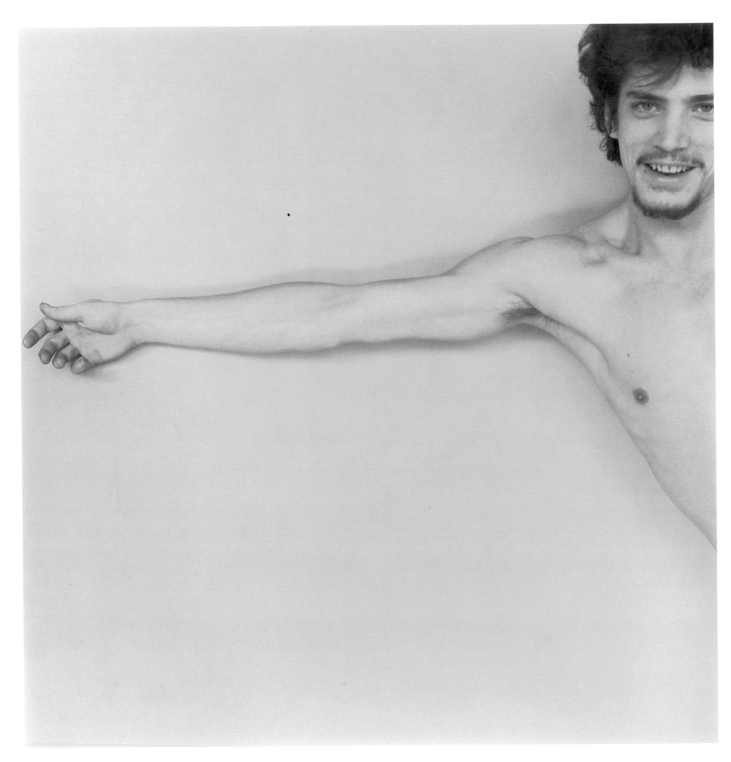

Self-Portrait, 1975

is the Artists desire to permeate existence
He does so by the power of his own presence
And by will alone he breathes a work into art.
As pumping air into a balloon, that when let go,
permeates the sky.

He sees perfection in a leaf or another mans
psyche. He is a city of veins and lead;
building and rebuilding the same chapel,
the same marble stairway.

As one walks these stairs and looks around
one notes a gallery of light wars. That is all.
A ship dissolving into an atmosphere, into sea.
And when night falls—the light as well.
And all disappears into walls. No more
luminous than a moon. Composed of love
and will alone.

And the Artist does indeed love.
In love with his own process.
reaffirms his mastery, his mystery.
testament of his own life force and also
his gift to humanity.

Certain gifts are chosen and arranged in retrospect.
The Artist machetes a clearance. Here one can be spared
the pain and the extravagance of the entire body and
be transported by snaking thru a glittering fraction.

His gifts, his children, travel beyond the eye
and hand that spun them into existence.
A lifetime of work letting go
of one who has weathered innocence.
pressed laurels upon intelligence
all with the generosity
of a transforming
smile.

Patti Smith
June 1988

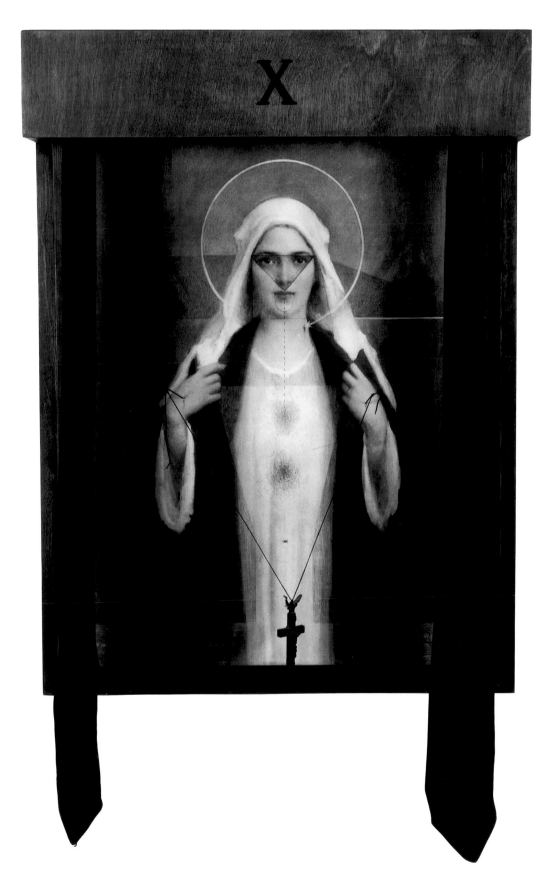

Tie Rack, 1969

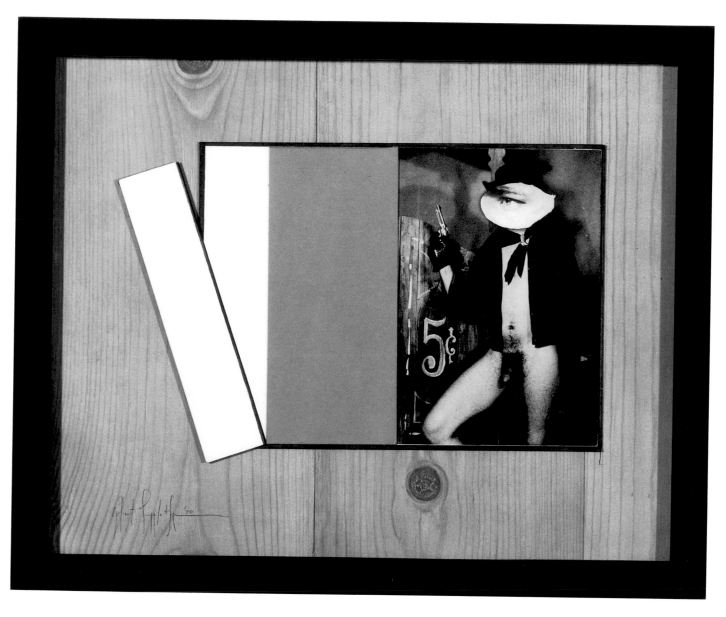

Cowboy, 1970

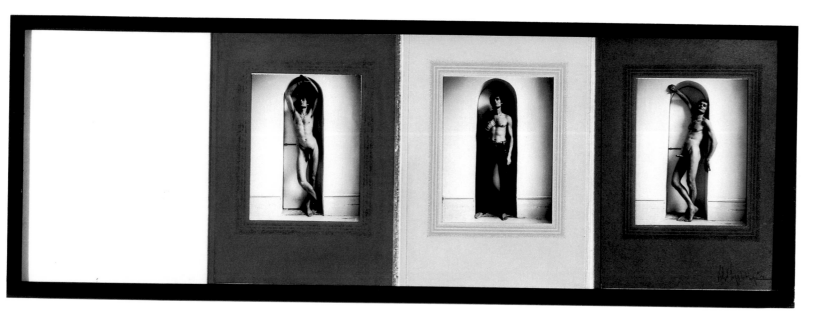

Manfred, 1974

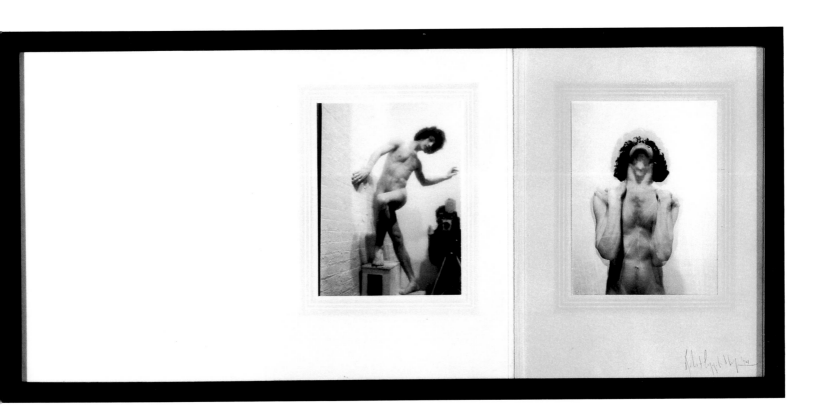

Dancer, 1974

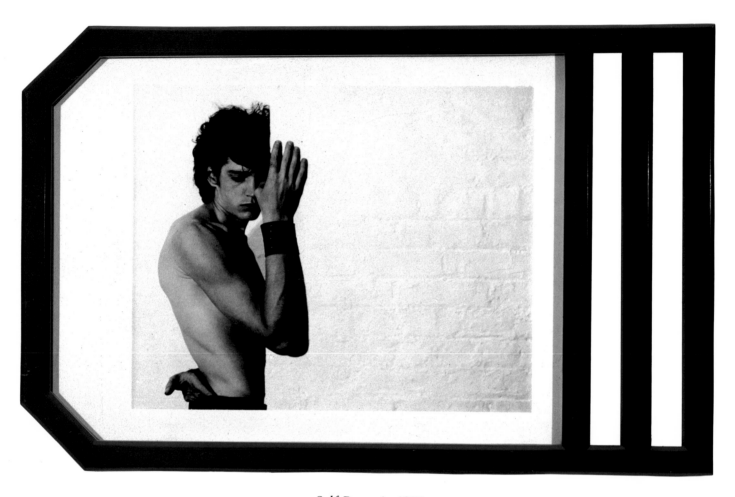

Self-Portrait, 1974

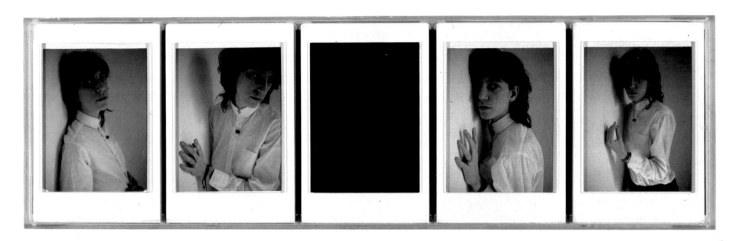

Patti Smith, Don't Touch Here, 1973

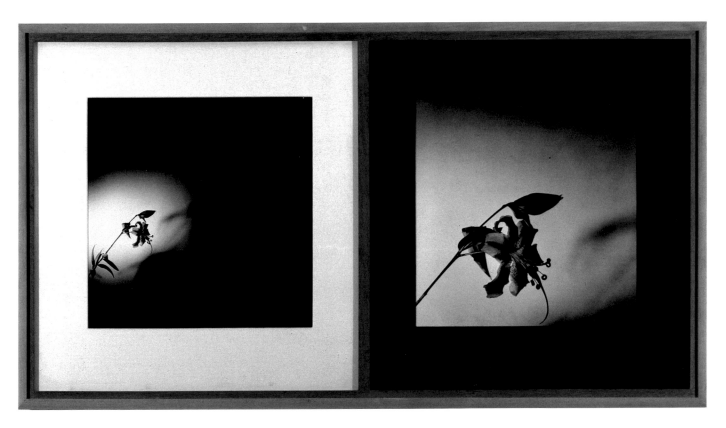

Tiger Lily, 1977

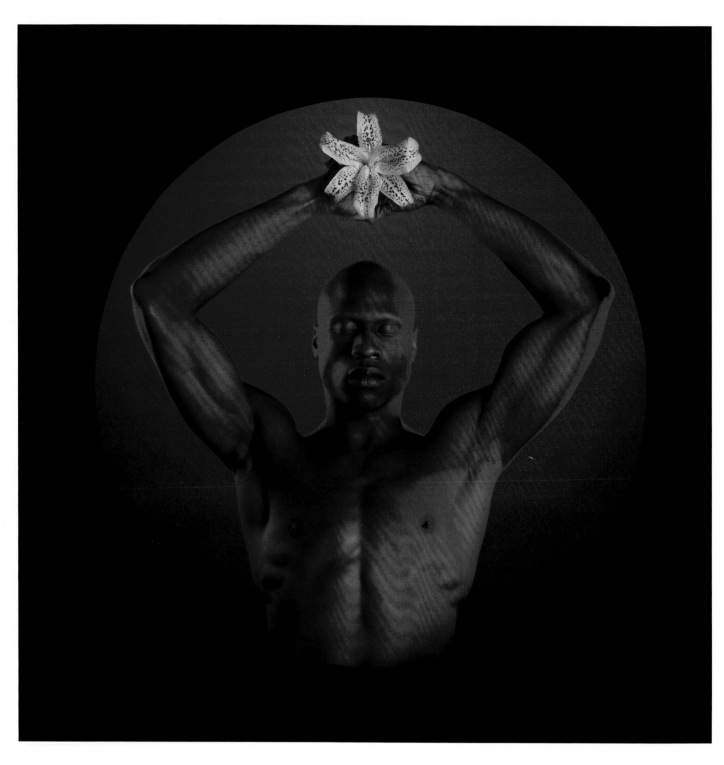

Ken Moody, 1984

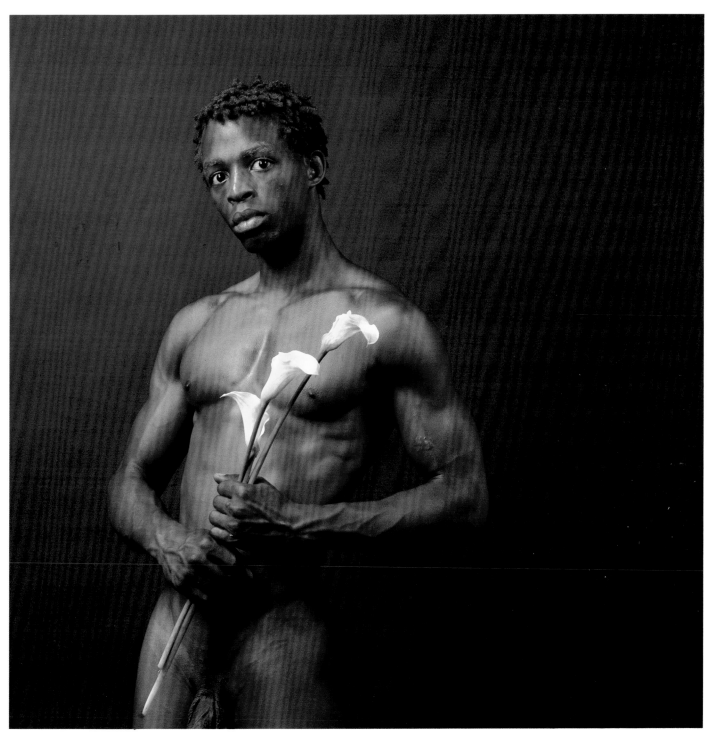

Dennis Speight with Calla Lilies, 1983

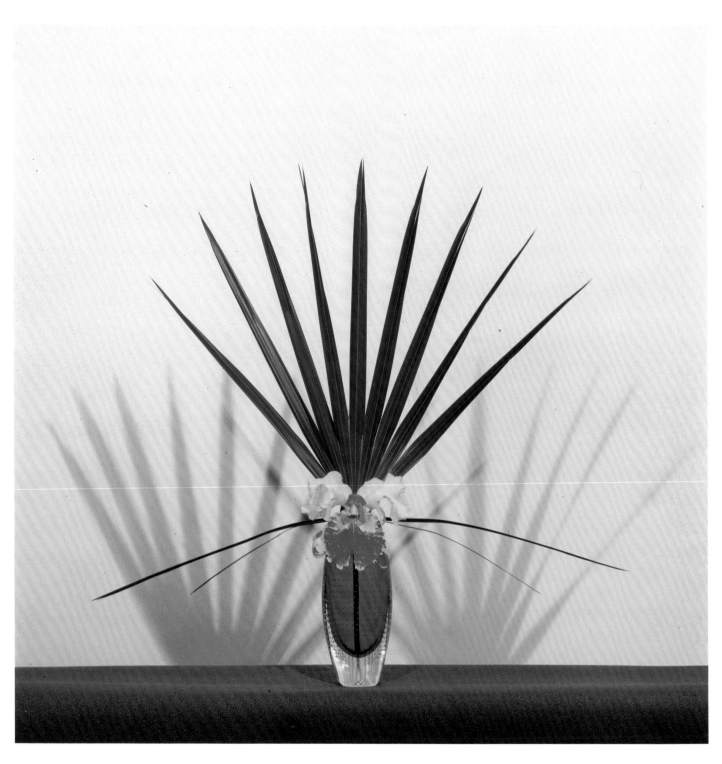

Orchid and Palmetto, 1982

Jesse McBride, 1976

Honey, 1976

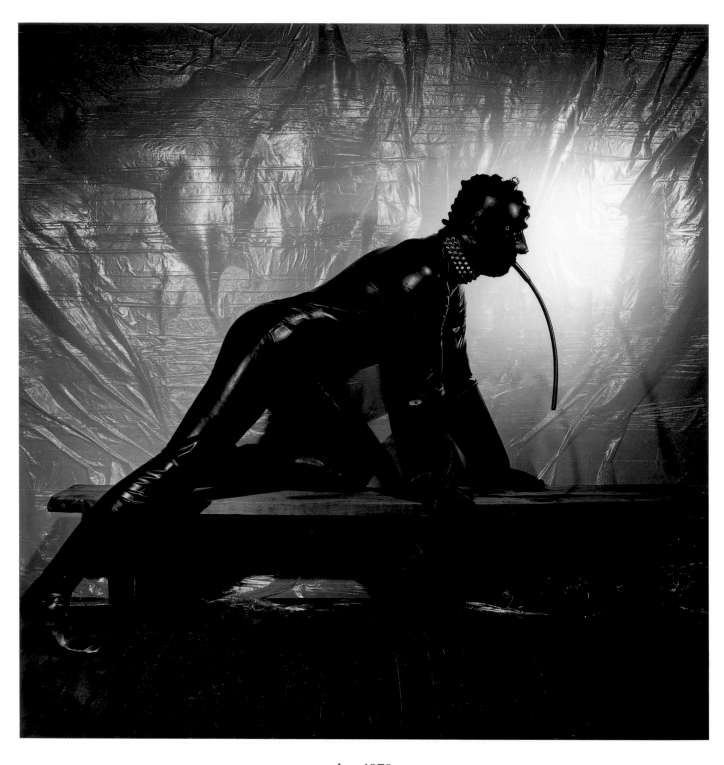

Joe, 1978

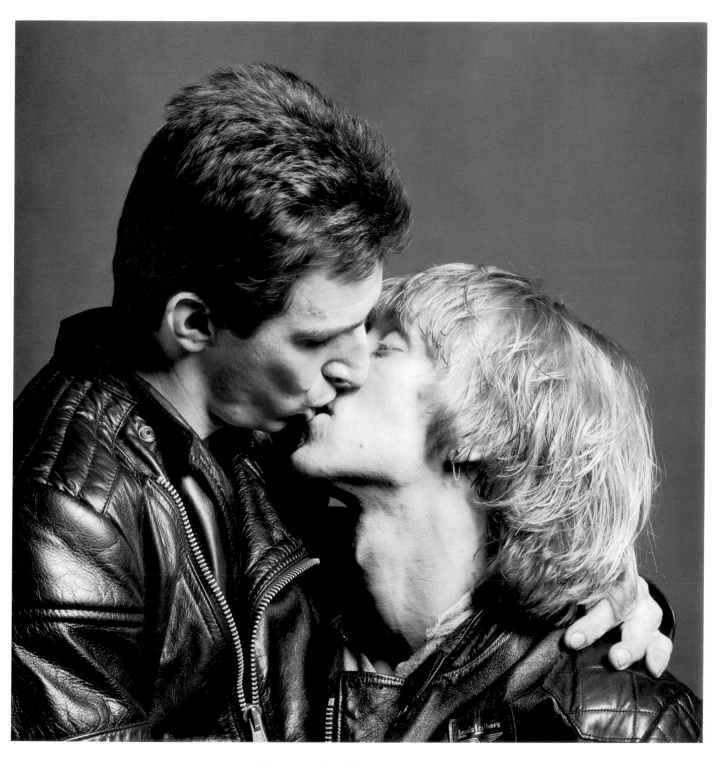

Larry and Bobby Kissing, 1979

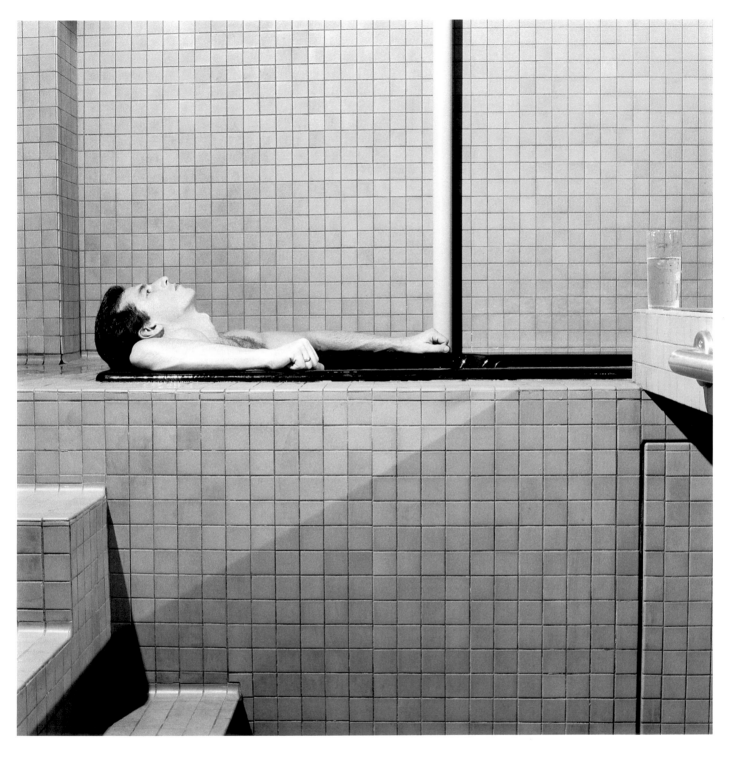

James Ford, 1979

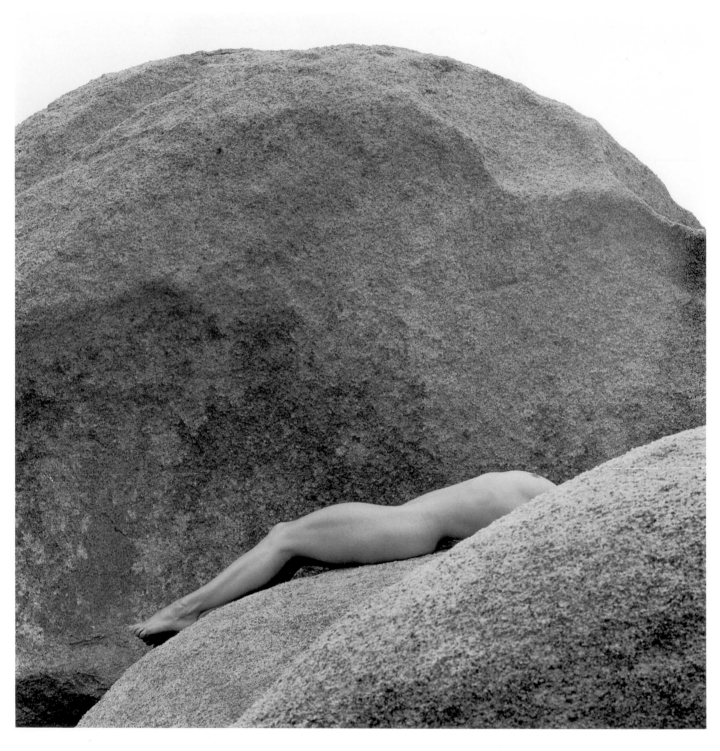

Lisa Lyon, 1980

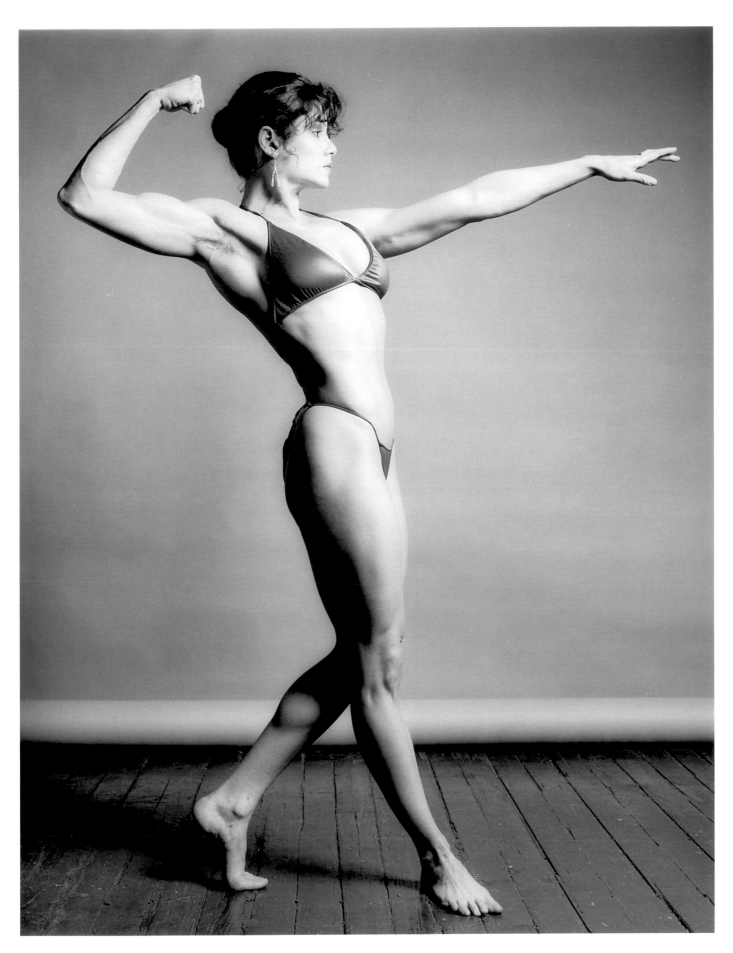

Lisa Lyon, 1982

55

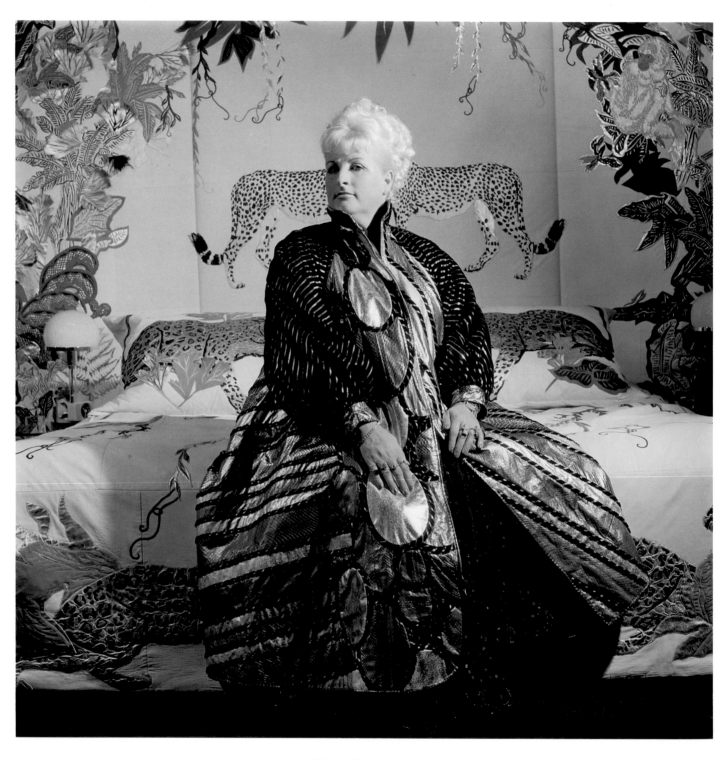

Miep Brons, 1980

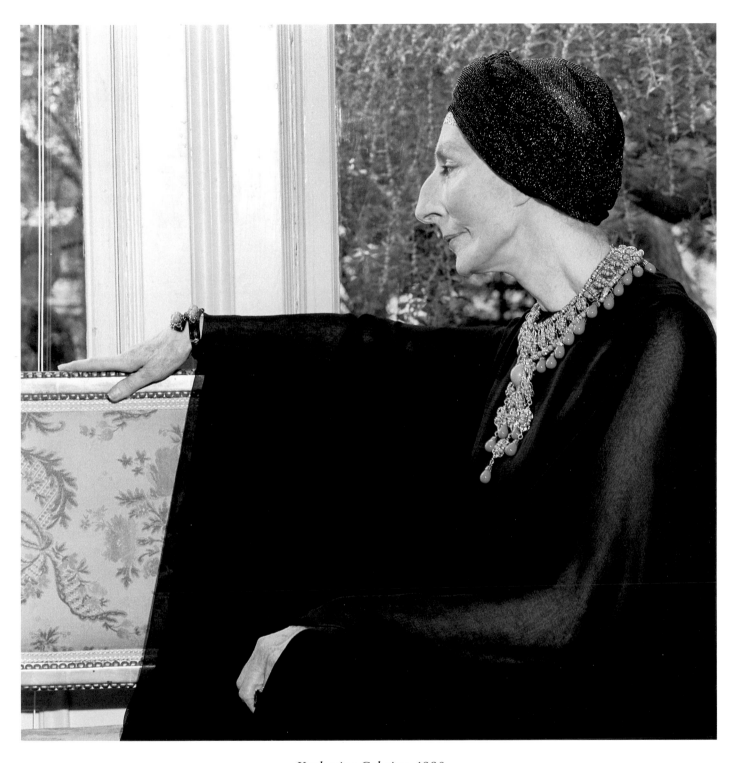

Katherine Cebrian, 1980

Embrace, 1982

59

David Hockney and Henry Geldzahler, 1976

American Flag, 1977

William Burroughs, 1980

Leo Castelli, 1982

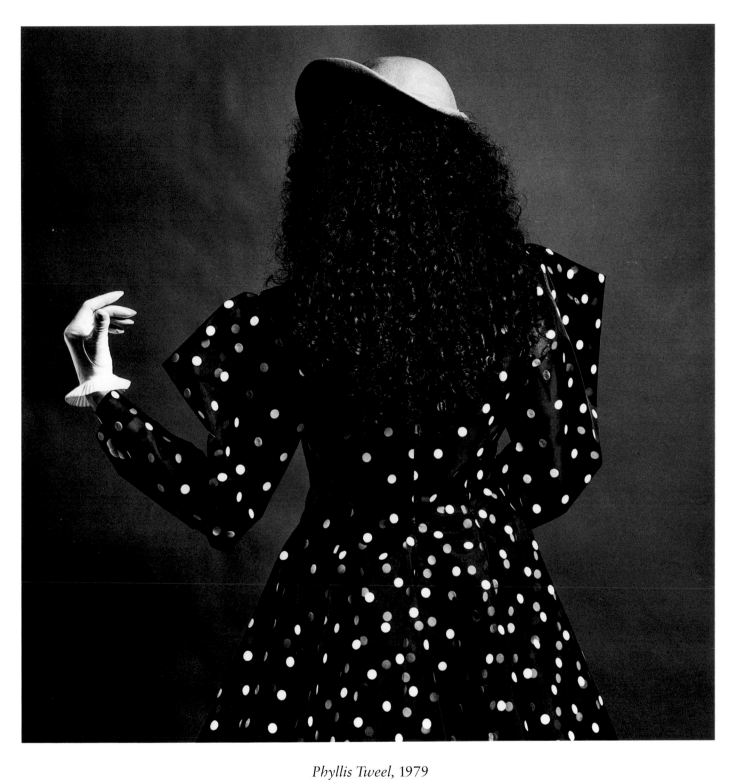

Phyllis Tweel, 1979

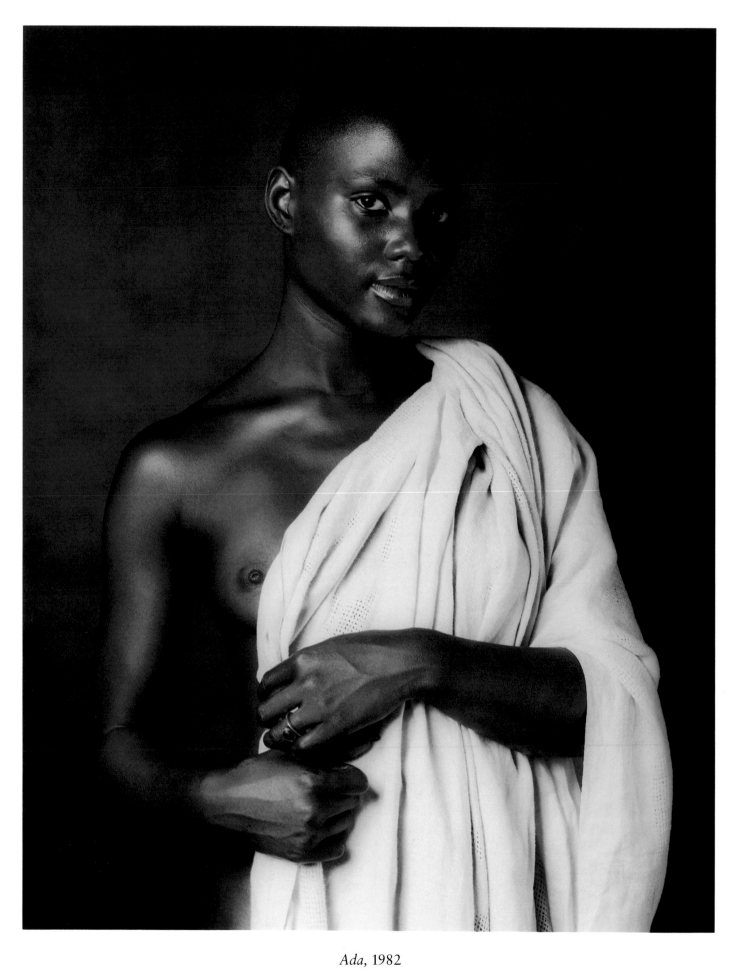

Ada, 1982

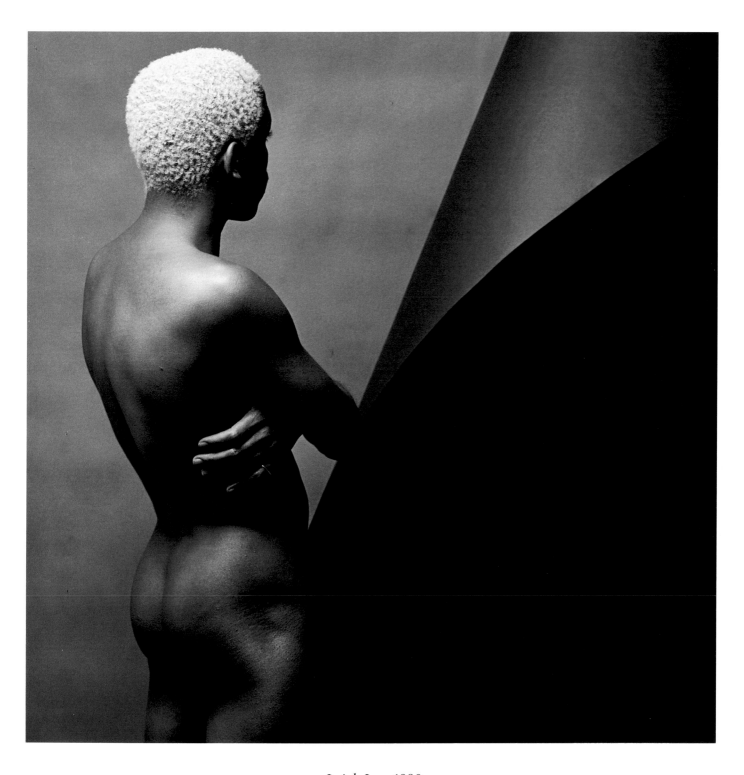

Leigh Lee, 1980

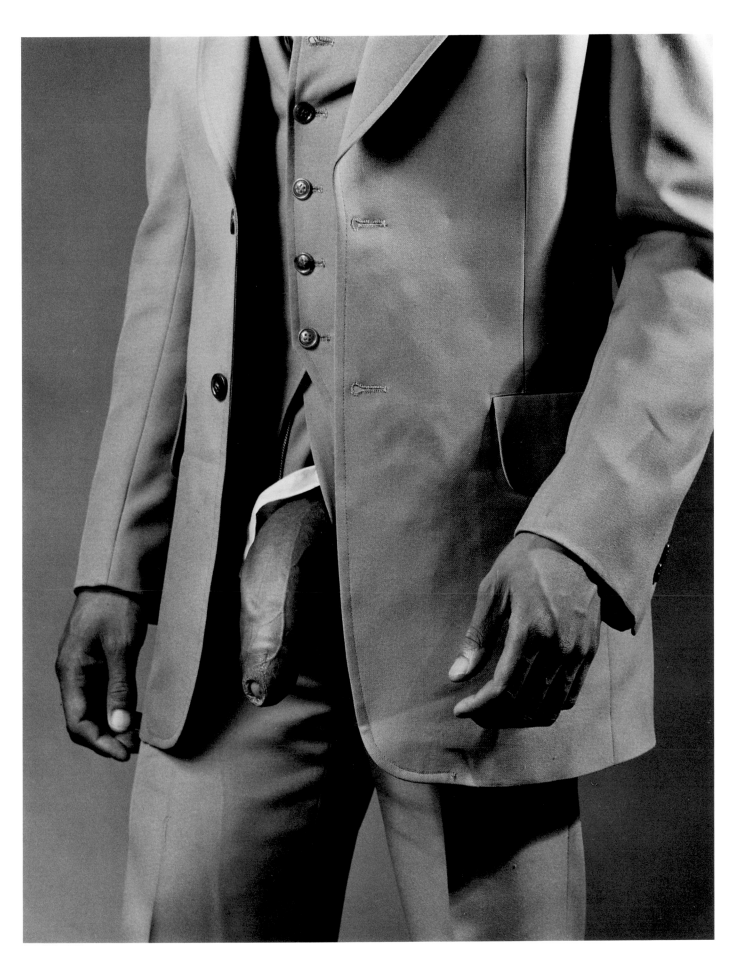

Man in Polyester Suit, 1980

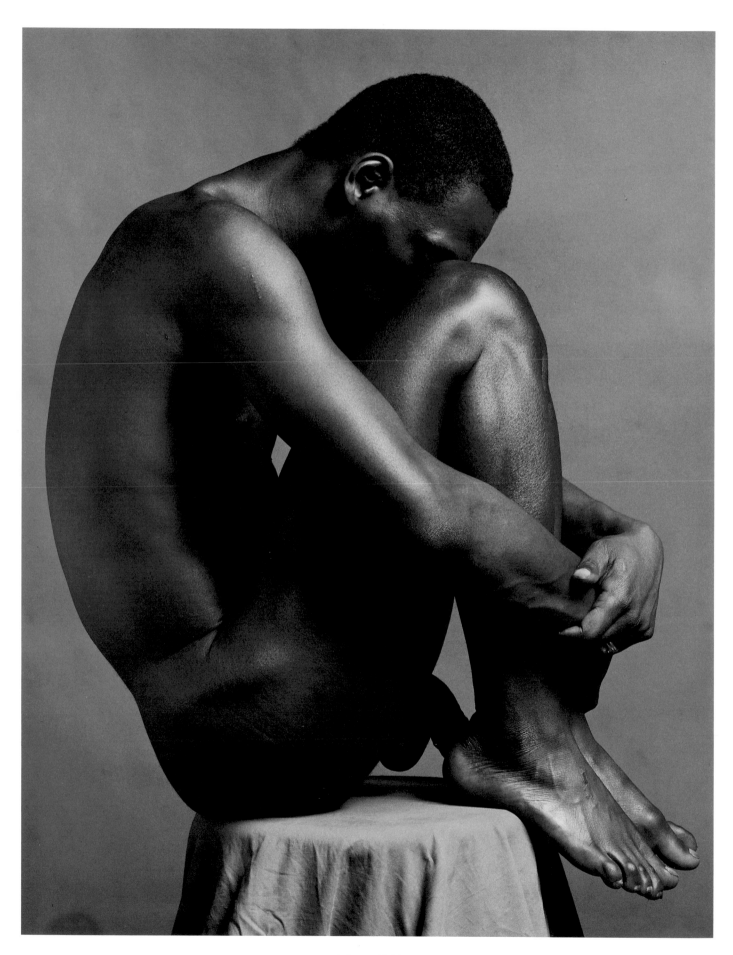

Ajitto, 1981

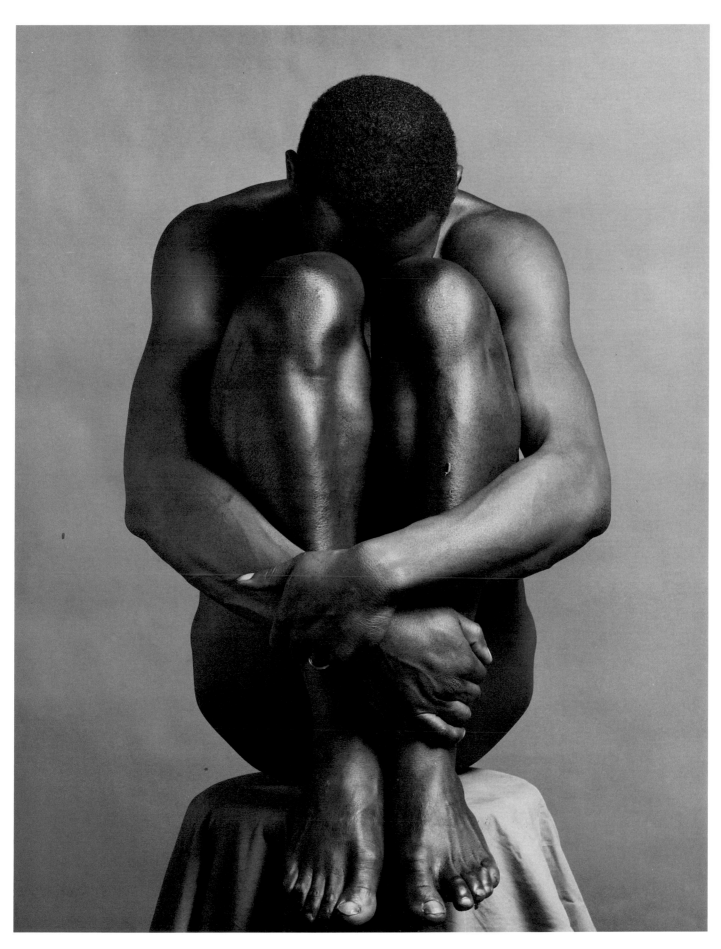

Ajitto, 1981

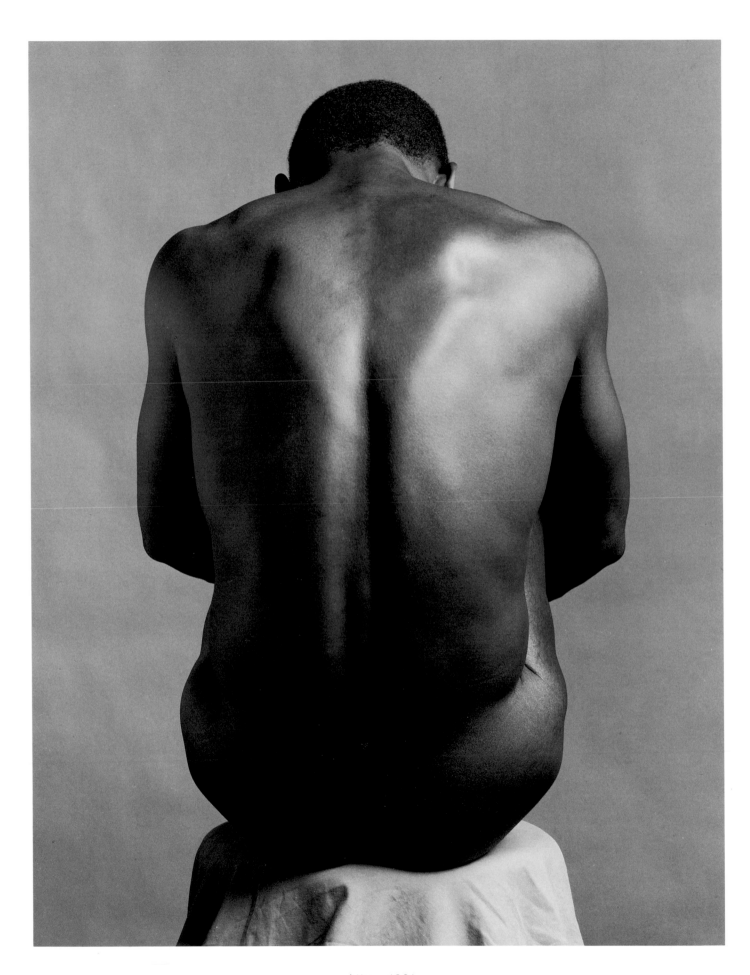

Ajitto, 1981

72

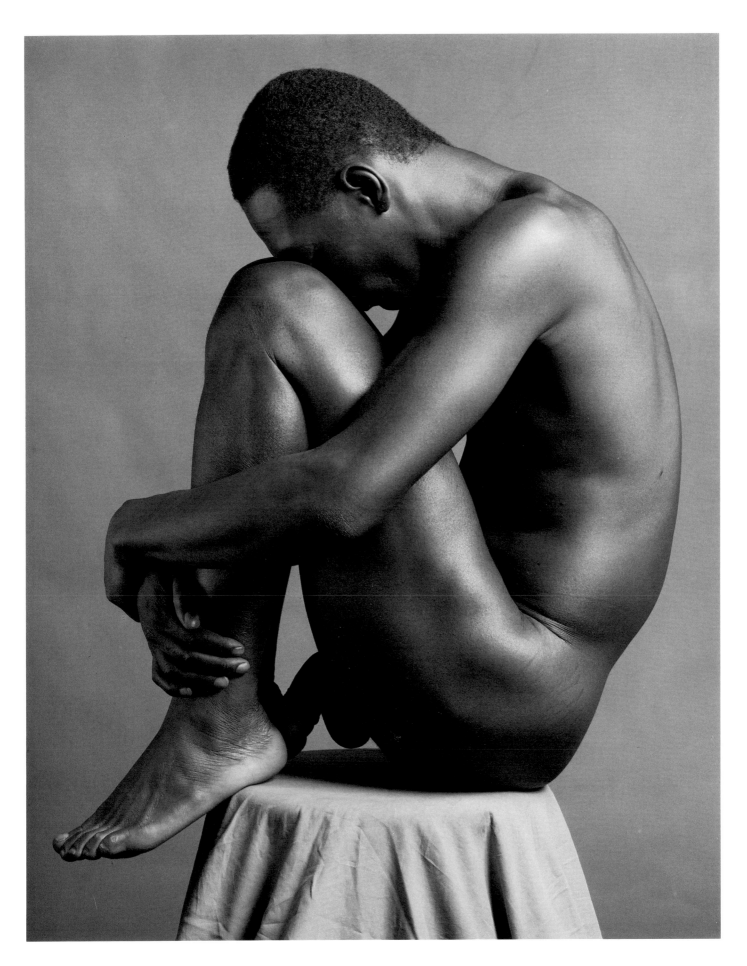

Ajitto, 1981

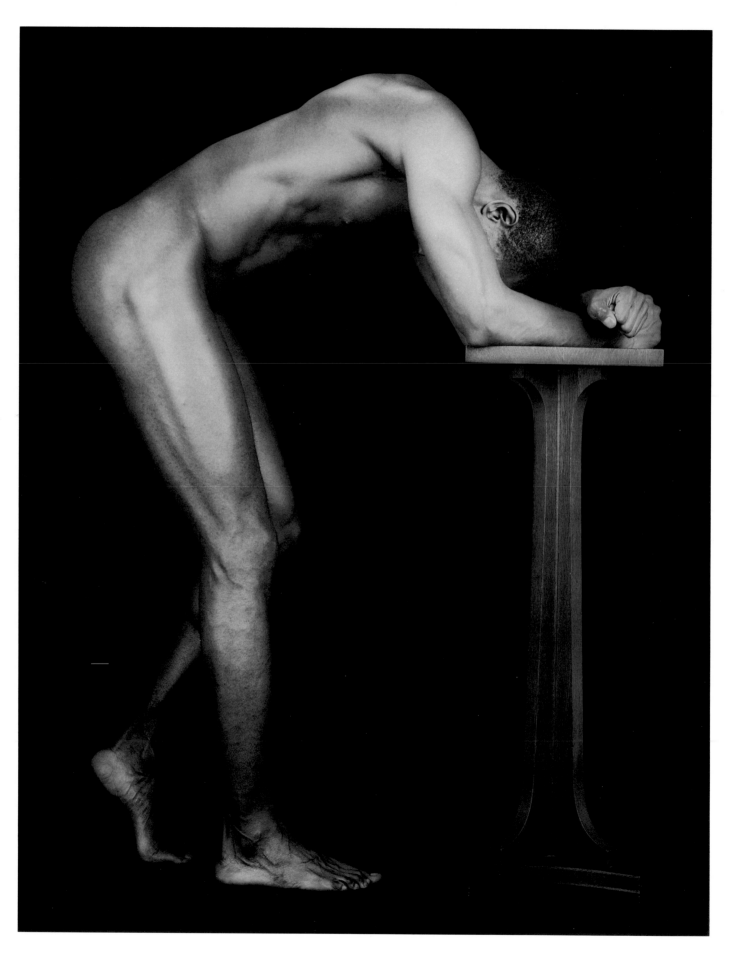

Thomas on a Pedestal, 1986

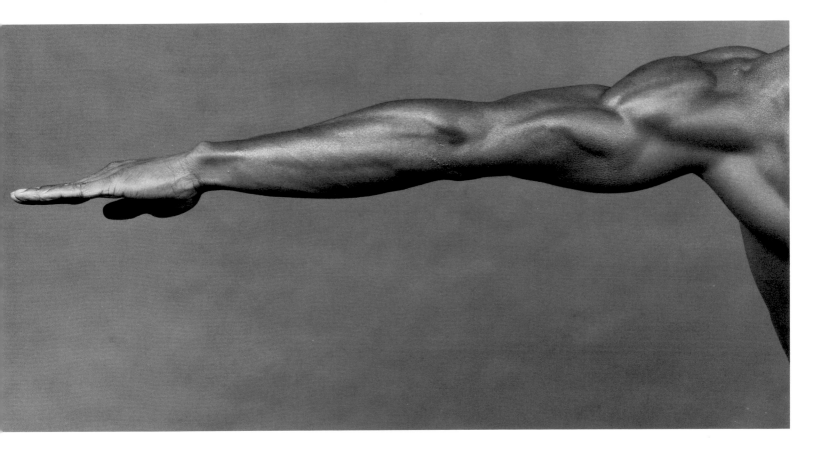

Derrick Cross, 1982

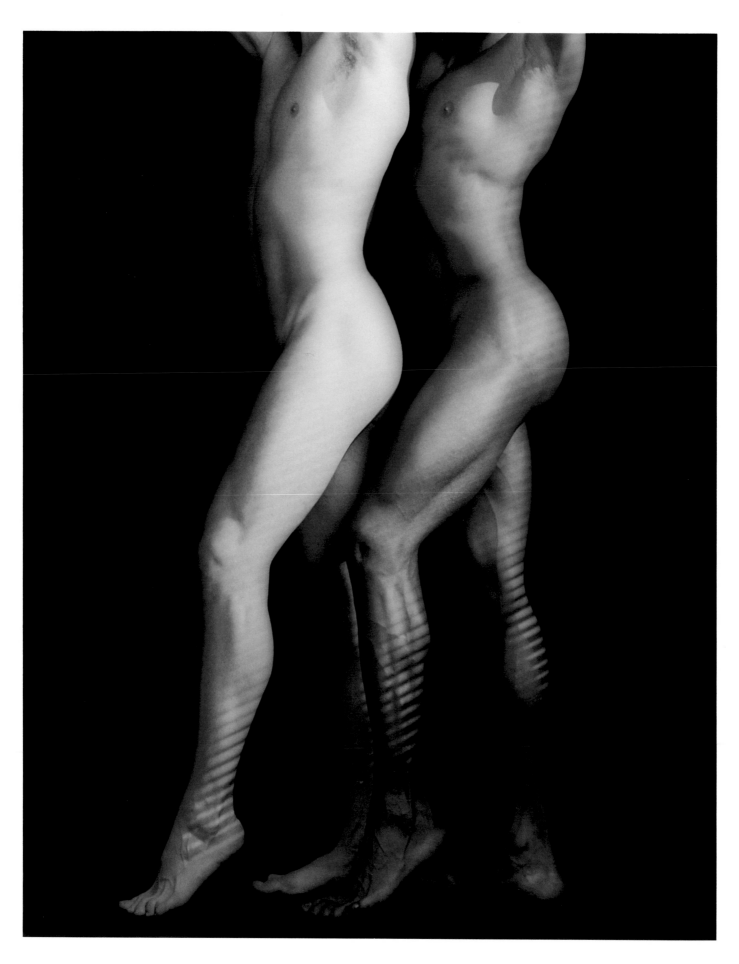

Ken and Tyler, 1985

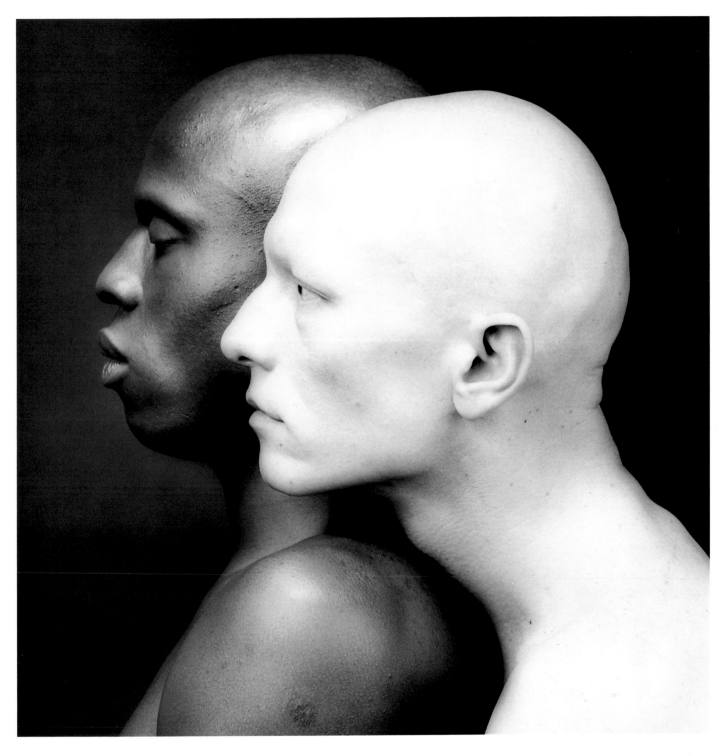

Ken Moody and Robert Sherman, 1984

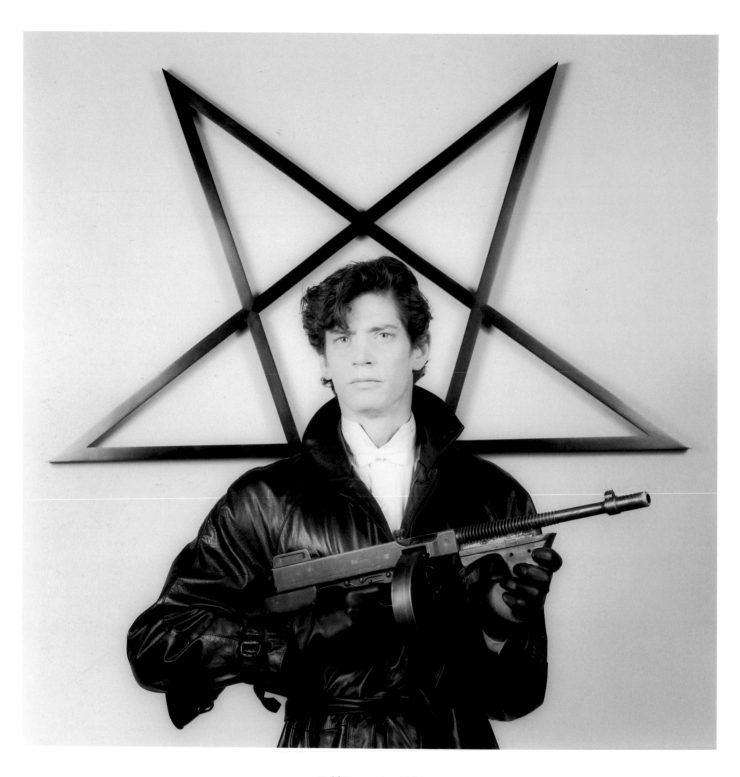

Self-Portrait, 1983

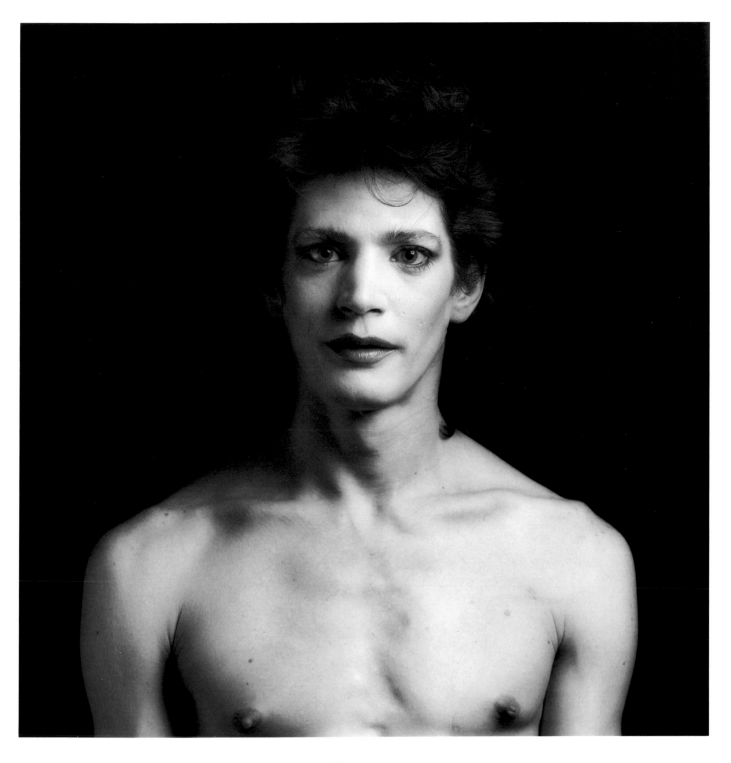

Self-Portrait, 1980

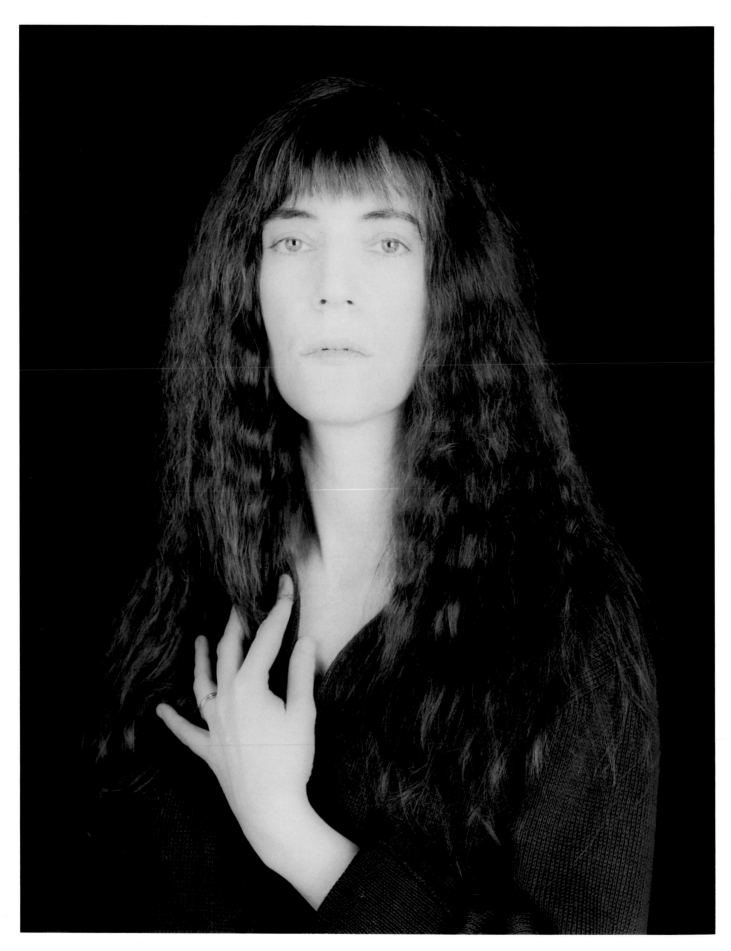

Patti Smith, 1986

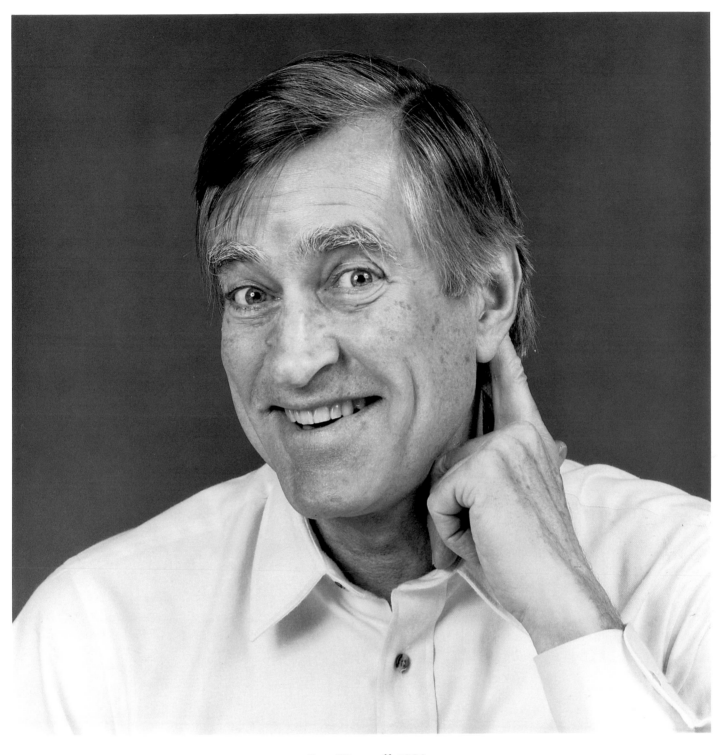

Sam Wagstaff, 1983

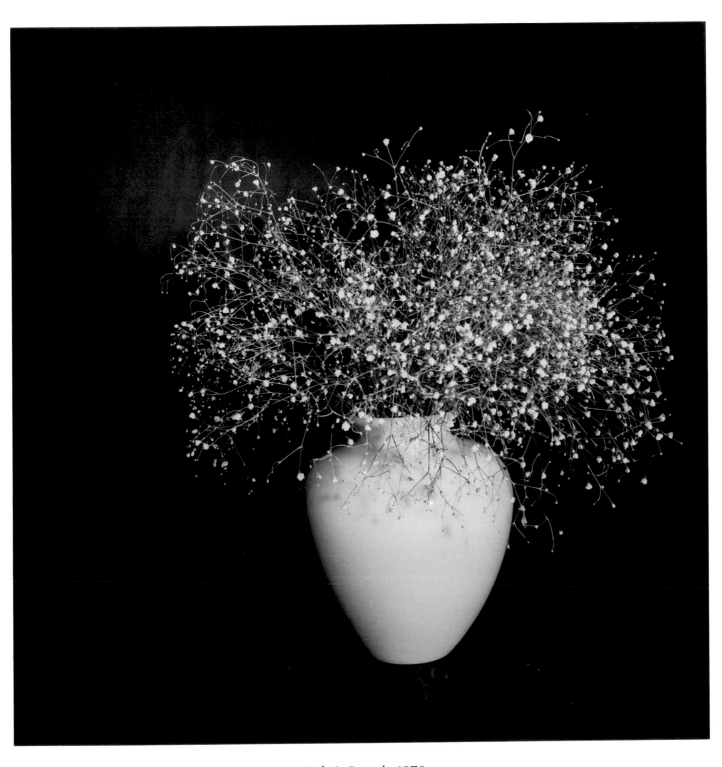

Baby's Breath, 1978

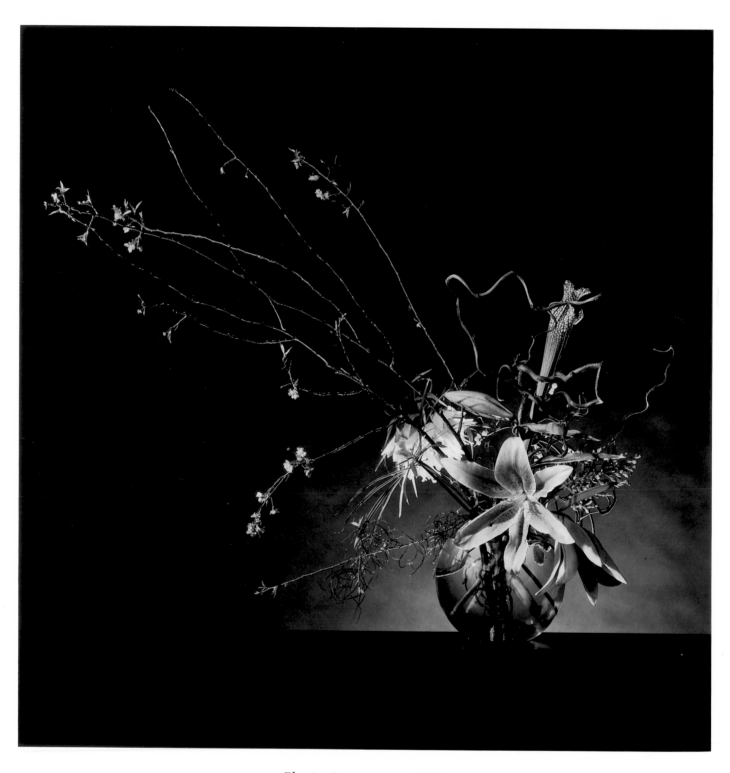

Flower Arrangement, 1982

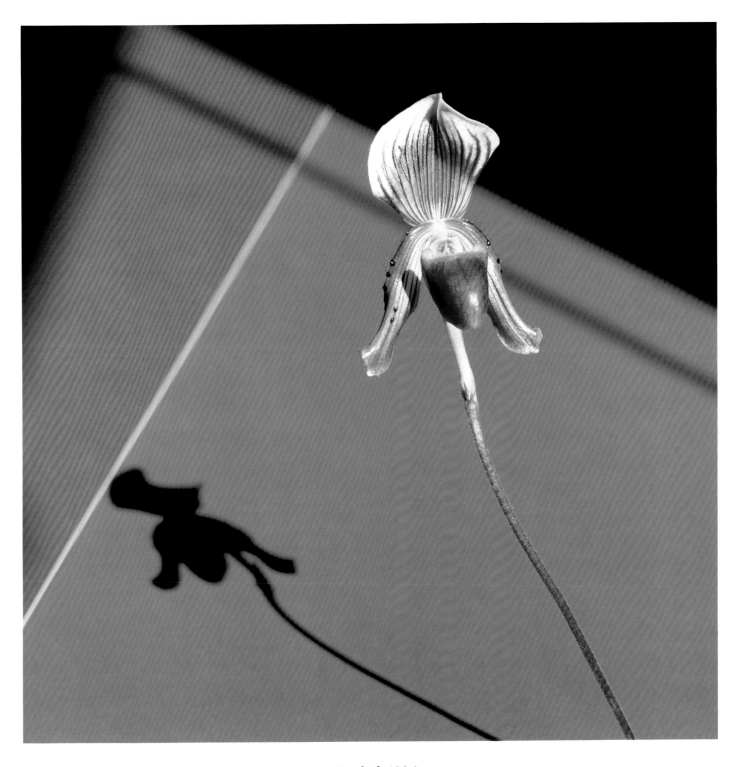

Orchid, 1986

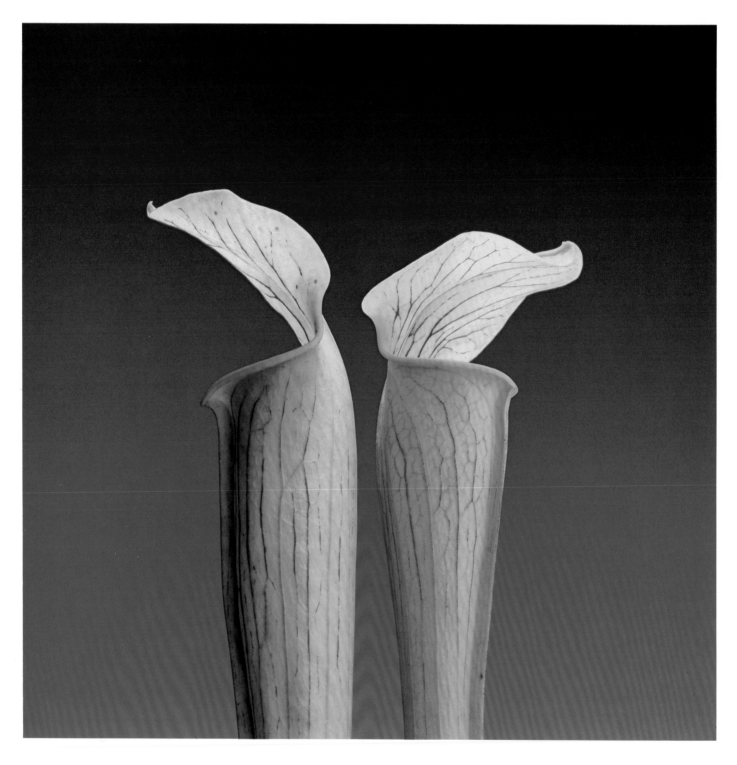

Double Jack-in-the-Pulpit, 1988

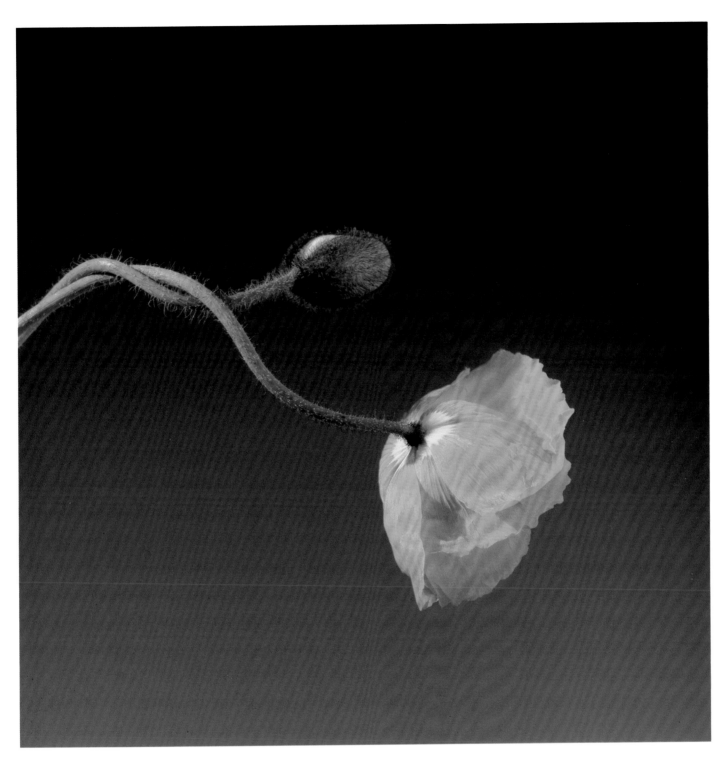

Poppy, 1988

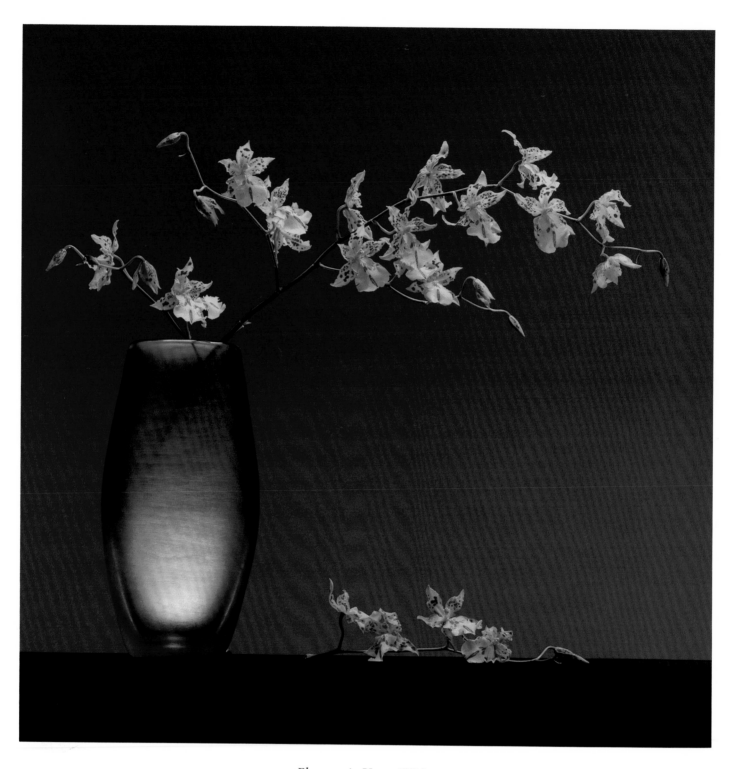

Flowers in Vase, 1985

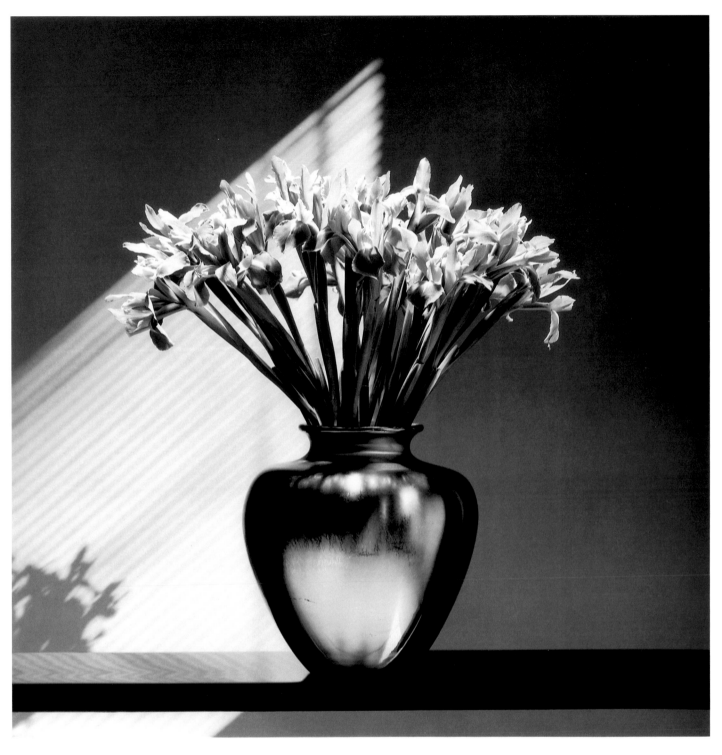

Irises, 1986

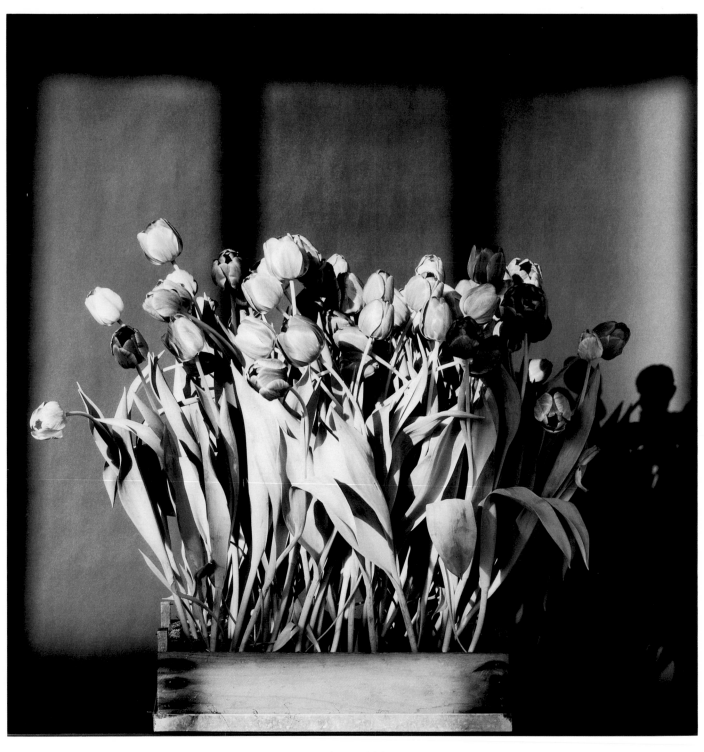

Tulips, 1983

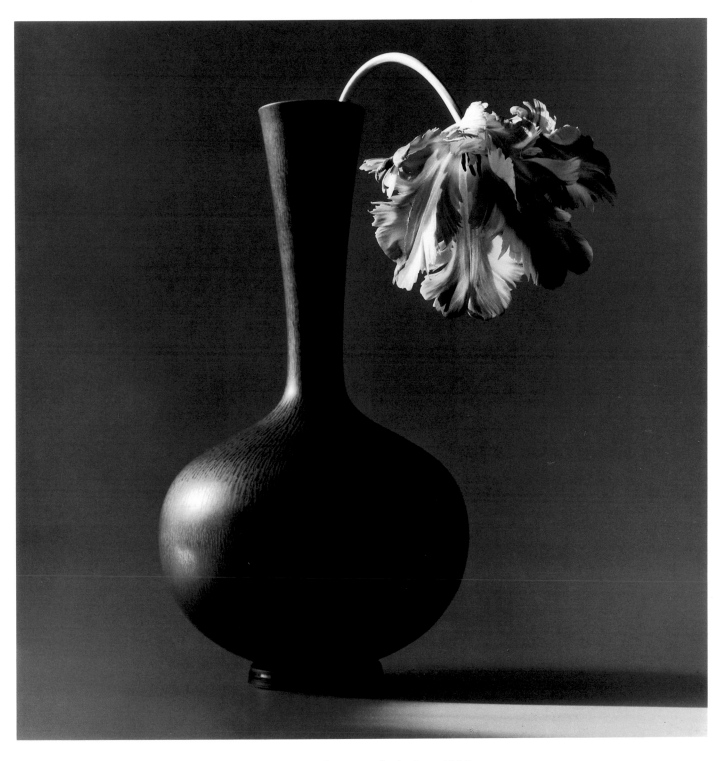

Parrot Tulip in a Black Vase, 1985

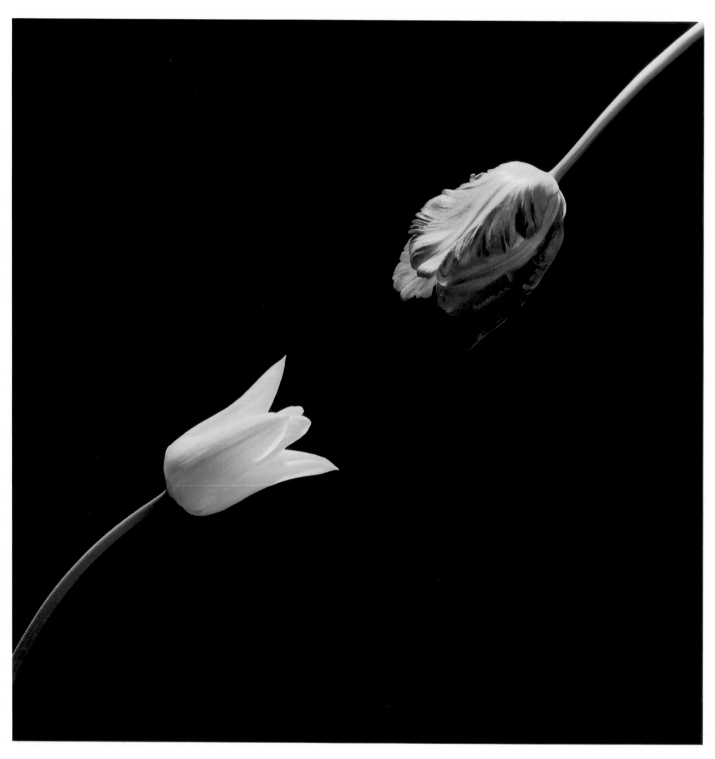

Tulips, 1984

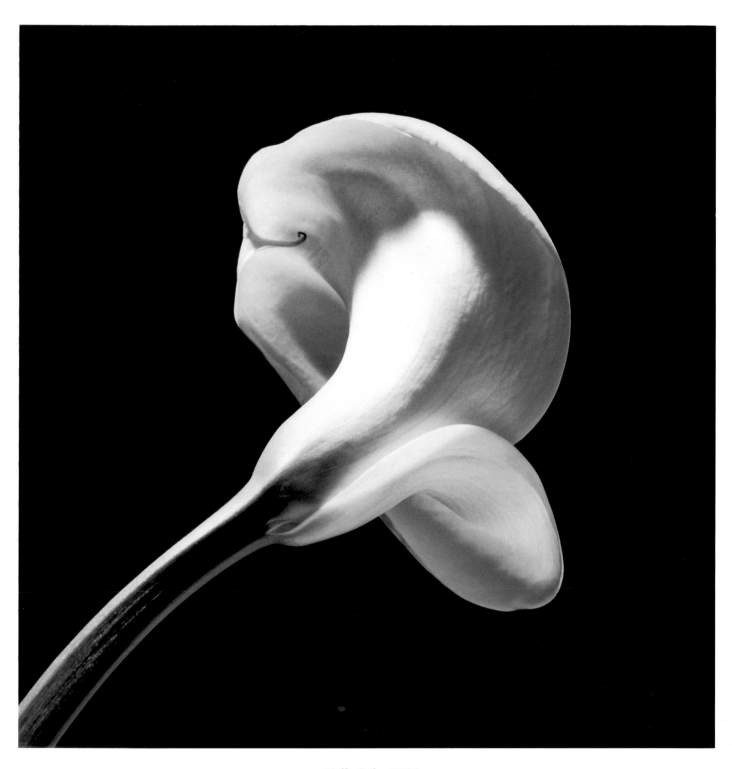

Calla Lily, 1984

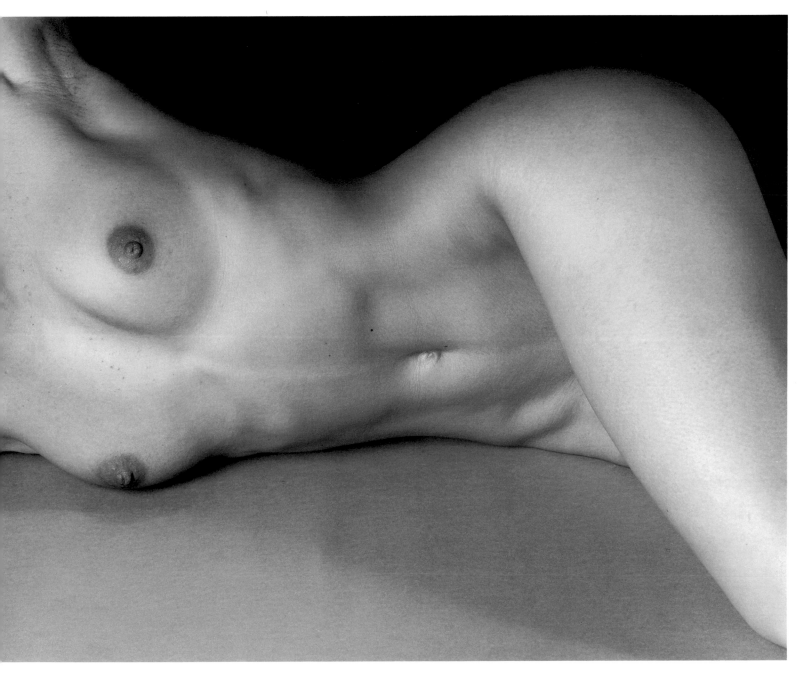

Lydia Cheng, 1987

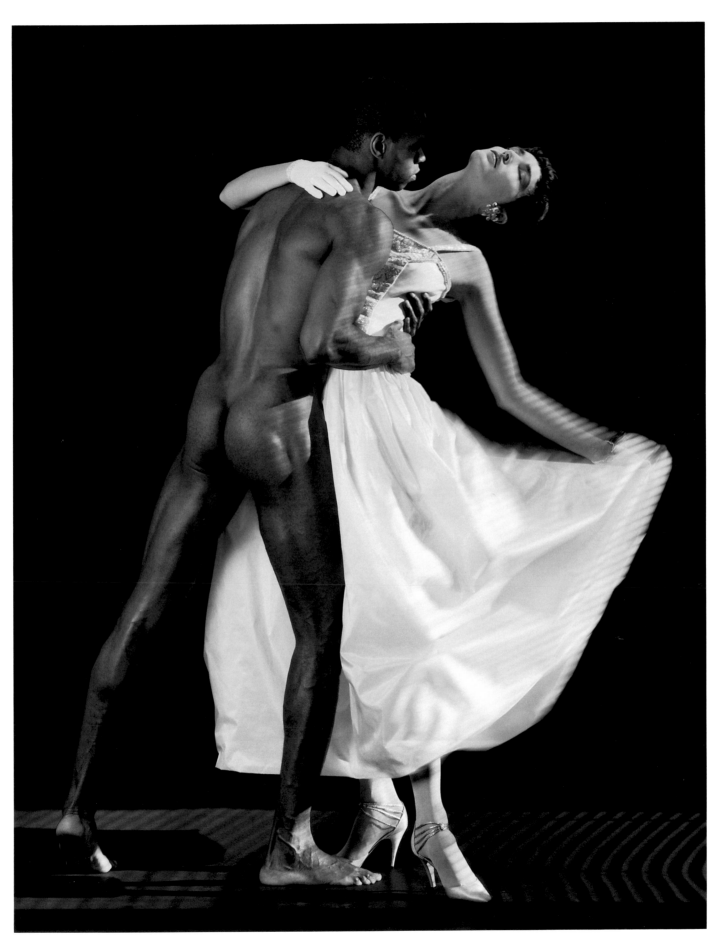

Thomas and Dovanna, 1986

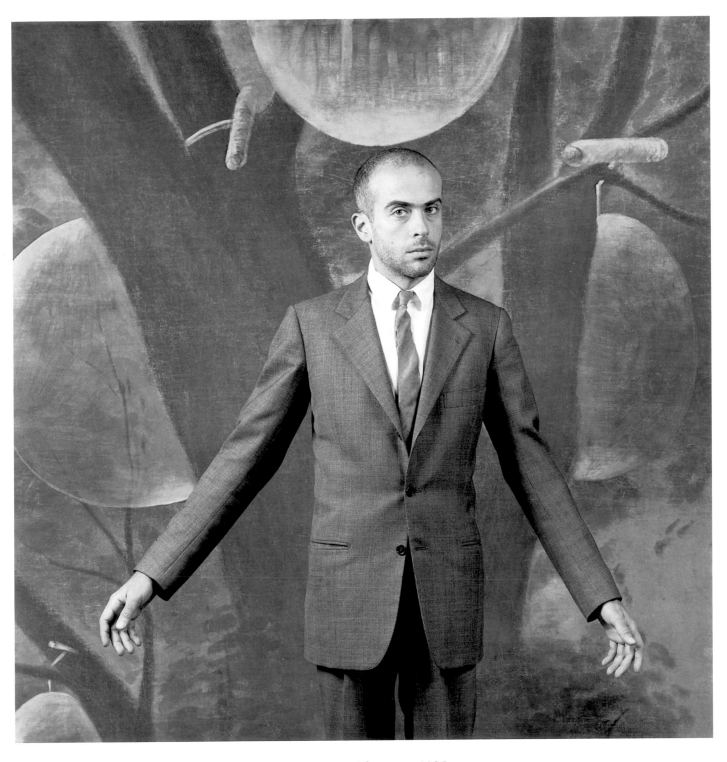

Francesco Clemente, 1985

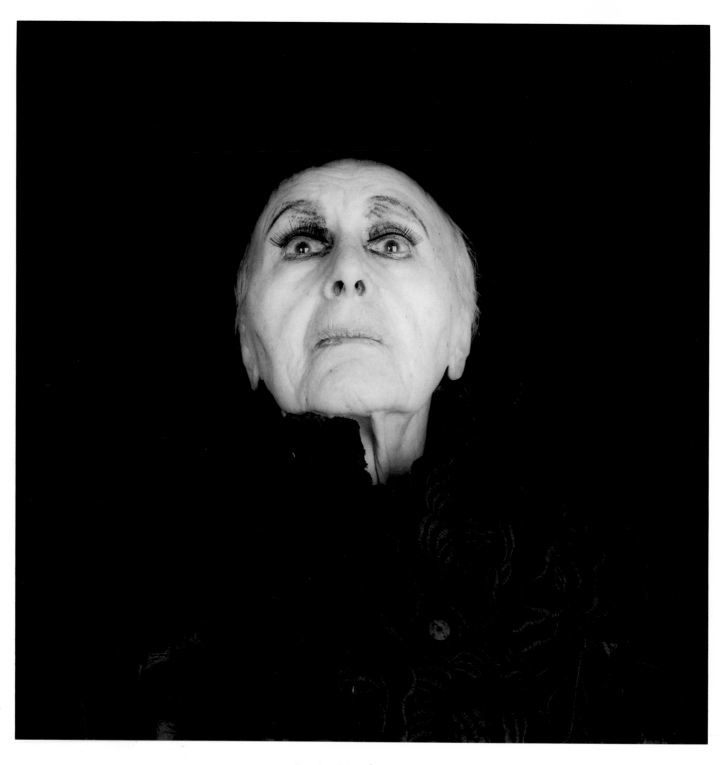

Louise Nevelson, 1986

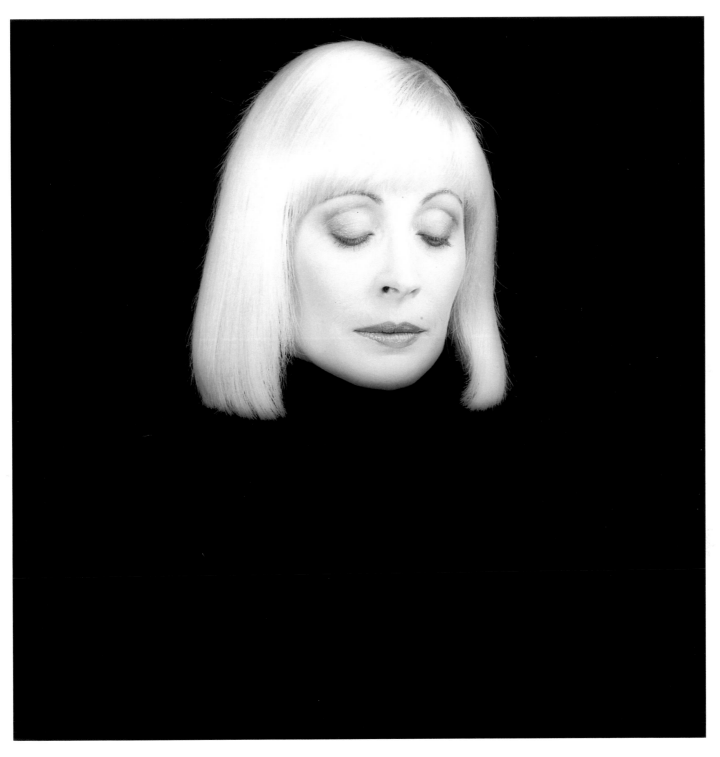

Doris Saatchi, 1983

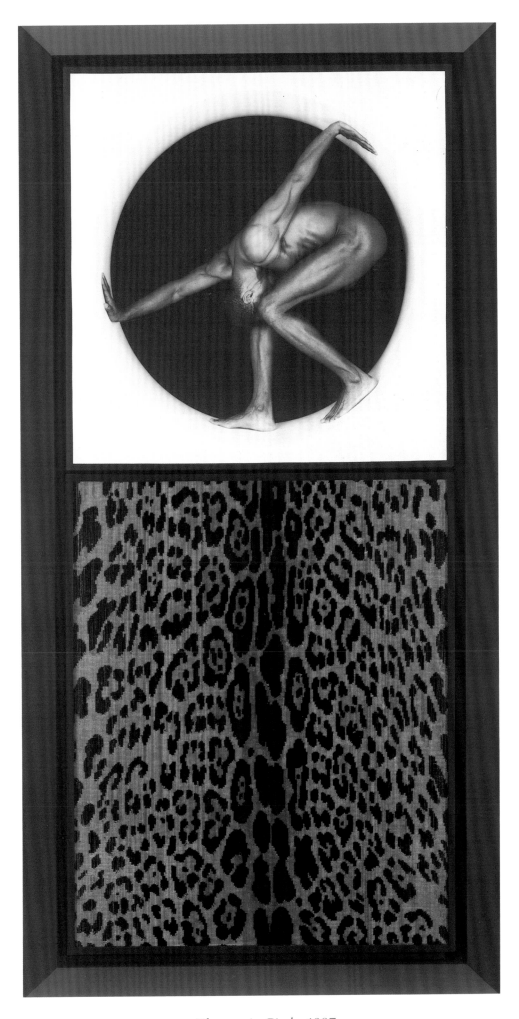

Thomas in Circle, 1987

103

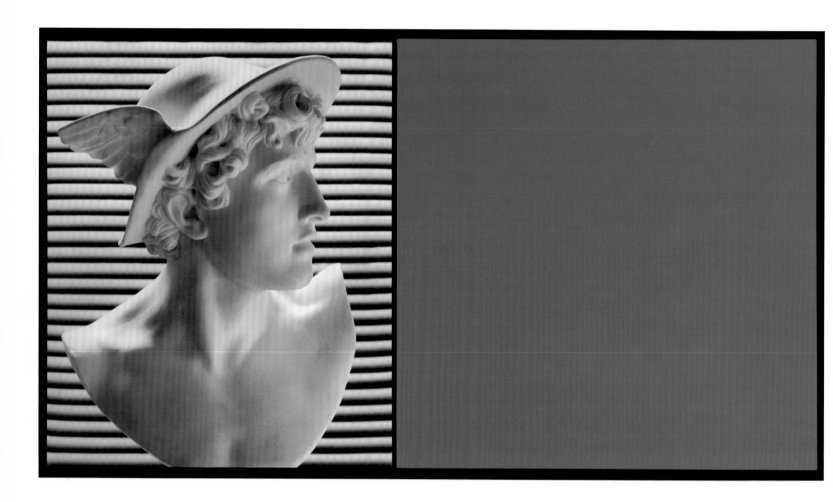

Mercury, 1987

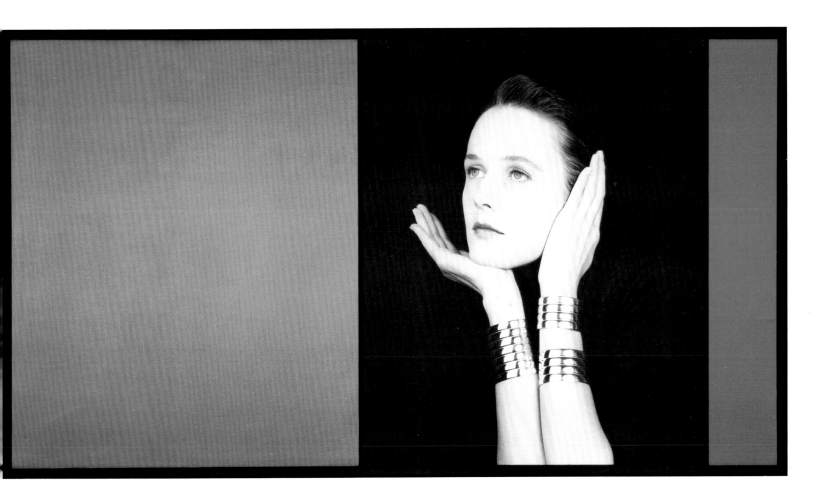

Lucy Ferry, 1987

Urn with Fruit, 1987

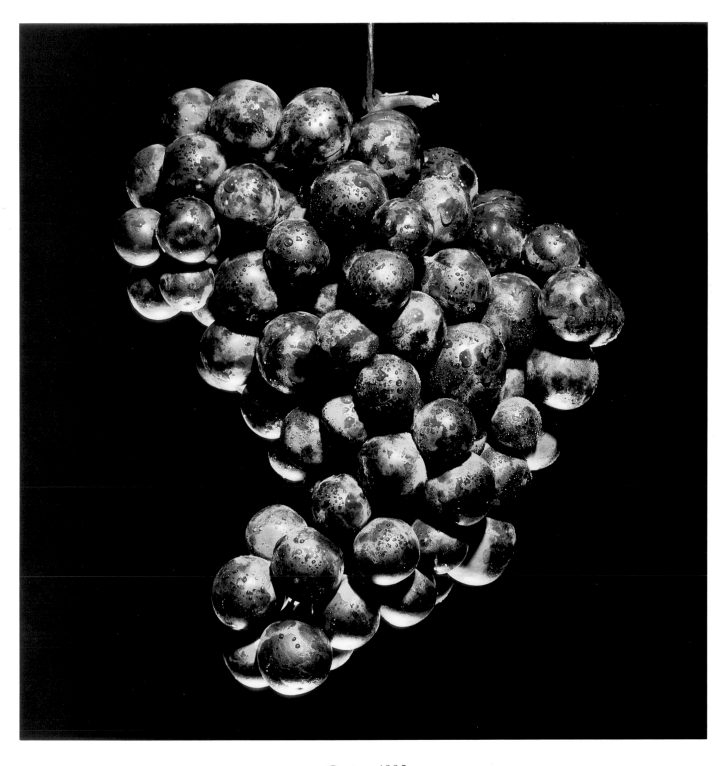

Grapes, 1985

Hermes, 1988

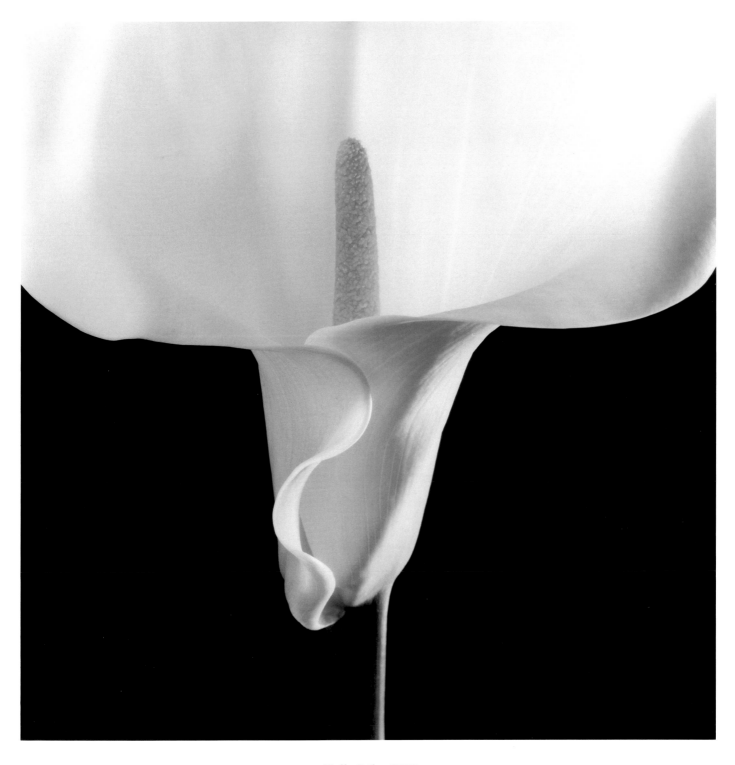

Calla Lily, 1988

Chest, 1987, collection Emily Fisher Landau

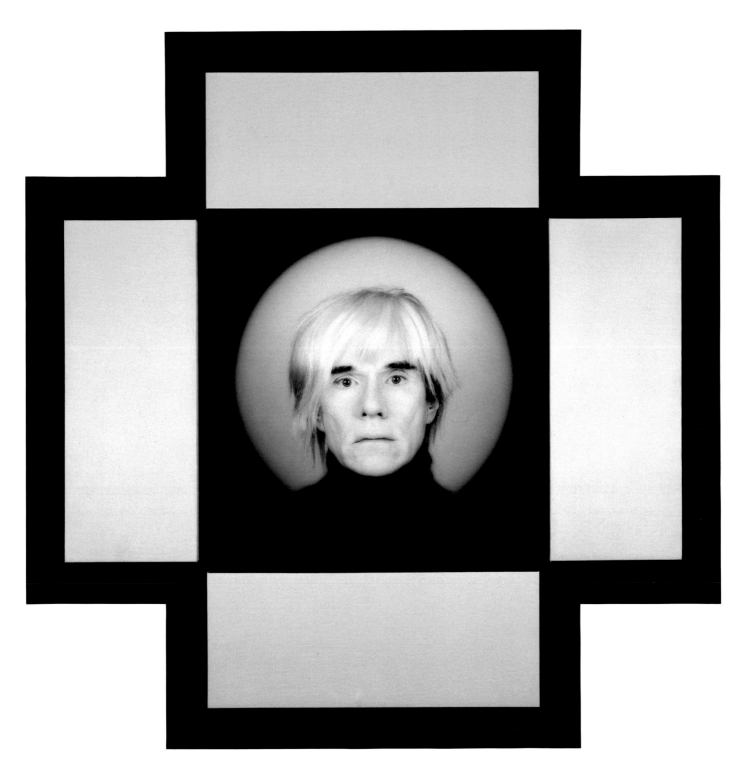

Andy Warhol, 1986

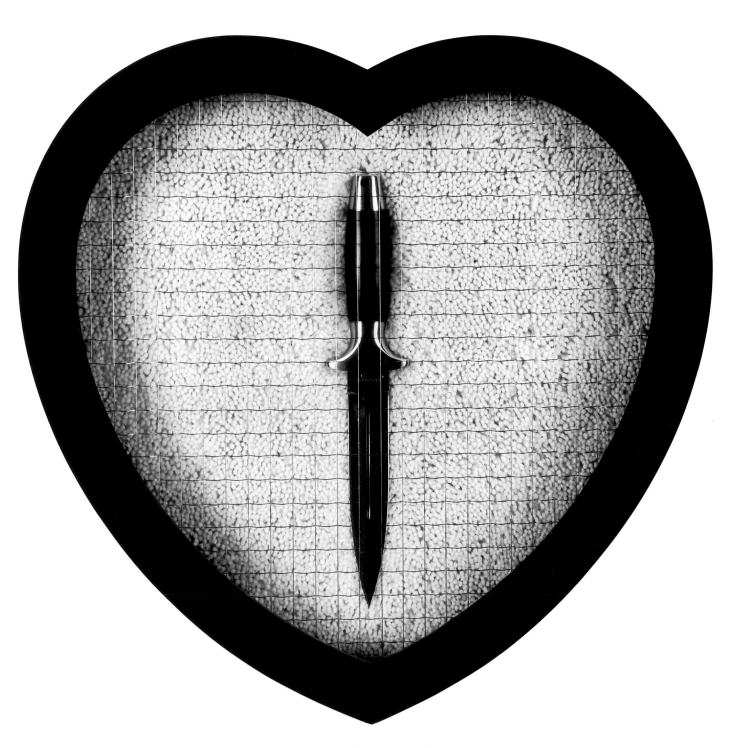

Heart and Dagger, 1982

CATALOGUE OF THE EXHIBITION

All dimensions are in inches; height precedes width precedes depth. Unless otherwise noted, these measurements are for paper size.

Robert Mapplethorpe makes his work in a variety of photographic processes and formats. Through 1979, sixteen-by-twenty-inch silver prints were made in editions of five. During 1980, this size was made in editions of fifteen; after 1981, they were printed in editions of ten.

Since 1985, Mapplethorpe has been making silver prints on twenty-by-twenty-four-inch paper in editions of ten. Platinum prints on twenty-two-and-one-half-by-twenty-five-inch paper are made in editions of three. Works composed of platinum emulsion on linen are made in editions of two—one a multipanel object with fabric, the other framed by itself. Dye transfer prints are made in editions of seven. Cibachrome prints are made in editions of three. Portfolios are in editions of twenty-five, plus six artist's proofs.

Pieces that do not fall into these categories are not in editions. When such elements as fabric, mats, mirrors, and frames are integral to the composition, the overall dimensions of the piece are given.

All works from the estate of the artist are lent to the exhibition courtesy of Robert Miller Gallery, New York.

*Exhibited only at Institute of Contemporary Art, Philadelphia.
**Exhibited only at Institute of Contemporary Art, Philadelphia, and Museum of Contemporary Art, Chicago.
†Exhibited only at Washington Project for the Arts, Washington, D.C.

STILL LIFES

American Flag, 1977
Silver print
20 × 16
Collection the estate of Robert Mapplethorpe

Tiger Lily, 1977
2 silver prints with silk mat and frame
Each 13½ × 13½, overall 23 × 42¼
Collection the estate of Robert Mapplethorpe

Baby's Breath, 1978
Silver print with silk mat
Overall 20¾ × 20¾
Private collection, New York

Y Portfolio, 1978
Tulips, N.Y.C., 1977
Irises, N.Y.C., 1977
Amaryllis, Paris, 1977
Tuberose, N.Y.C., 1977
Buds (Lily), N.Y.C., 1977
Lily, N.Y.C., 1977
Rose, N.Y.C., 1977
Orchid, N.Y.C., 1977
Chrysanthemum, N.Y.C., 1977
Baby's Breath, N.Y.C., 1978
Kale, N.Y.C., 1978
Gardenia, N.Y.C., 1978
Carnation, N.Y.C., 1978
13 silver prints mounted on board
Each 13½ × 13½
Collection the estate of Robert Mapplethorpe

Easter Lilies with Mirror, 1979
4 silver prints with mirror and shaped frame
Overall 49 × 49
Collection the estate of Robert Mapplethorpe

Flower, 1979
Silver print with silk mat
Image 13½ × 13½, overall 25 × 25
Collection the estate of Robert Mapplethorpe

Flower Arrangement, 1982
Silver print
20 × 16
Collection the estate of Robert Mapplethorpe

Orchid and Palmetto, 1982
Dye transfer print
20 × 16
Collection the estate of Robert Mapplethorpe

White Long-Stem Flower, 1982
Dye transfer print
20 × 16
Collection the estate of Robert Mapplethorpe

Orchid and Leaf in White Vase, 1982
Silver print
38 × 32
Collection Anne and Joel Ehrenkranz, New York

Tulips, 1983
Silver print
20 × 16
Collection the estate of Robert Mapplethorpe

Tulips, 1984
Silver print
20 × 16
Collection the estate of Robert Mapplethorpe

Calla Lily, 1984
Platinum print
25½ × 22
Collection Barbara and Bruce Berger, New York

Parrot Tulip in a Black Vase, 1985
Platinum print
25½ × 22
Collection the estate of Robert Mapplethorpe

Grapes, 1985
Platinum print
25½ × 22
Collection Harry H. Lunn, Jr., New York

Flowers in Vase, 1985
Dye transfer print
24 × 20
Collection the estate of Robert Mapplethorpe

Orchid with Diagonals, 1986
Dye transfer print
24 × 20
Collection the estate of Robert Mapplethorpe

Calla Lily, 1986
Silver print
40 × 40
Collection the estate of Robert Mapplethorpe

Flower Arrangement, 1986
Silver print
24 × 20
Collection the estate of Robert Mapplethorpe

Orchid, 1986
Dye transfer print
24 × 20
Collection the estate of Robert Mapplethorpe

Irises, 1986
Photogravure on silk mounted on paper
46 × 39¼
Collection the estate of Robert Mapplethorpe

Calla Lily, 1987
Dye transfer print and silver print
Each 24 × 20, overall 28½ × 48
Collection Dimitri Levas, New York

Parrot Tulip, 1987
Platinum emulsion on linen
25½ × 25½
Collection Evelyn Byrne, New York

Tulips, 1987
Platinum emulsion on linen
20 × 24
Private collection, San Francisco

Urn with Fruit, 1987
Dye transfer print
24 × 20
Collection the estate of Robert Mapplethorpe

*****Poppy*, 1988
Dye transfer print
24 × 20
Collection Andrew and Betsy Rosenfield, Chicago

Skull, 1988
Silver print
24 × 20
Collection the estate of Robert Mapplethorpe

Calla Lily, 1988
Silver print
24 × 20
Collection the estate of Robert Mapplethorpe

Double Jack-in-the-Pulpit, 1988
Dye transfer print
28 × 24
Collection the estate of Robert Mapplethorpe

Calla Lily, 1988
Dye transfer print
28 × 24
Collection the estate of Robert Mapplethorpe

Calla Lily, 1988
Dye transfer print
28 × 24
Collection the estate of Robert Mapplethorpe

Hermes, 1988
Silver print
24 × 20
Collection the estate of Robert Mapplethorpe

FIGURE STUDIES

Manfred, 1974
4 black-and-white Polaroids
Each 4½ × 3½, overall 8 × 24
Collection the estate of Robert Mapplethorpe

X Portfolio, 1978
Cedric, N.Y.C., 1977
Jim, Sausalito, 1977
Jim and Tom, Sausalito, 1977
Patrice, N.Y.C., 1977
Scott, N.Y.C., 1977
Joe, N.Y.C., 1978
Ken, N.Y.C., 1978
Helmut, N.Y.C., 1978
John, N.Y.C., 1978
Helmut and Brooks, N.Y.C., 1978
Lou, N.Y.C., 1978
Dick, N.Y.C., 1978
Self-Portrait, N.Y.C., 1978
13 silver prints mounted on board
Each 13½ × 13½
Collection the estate of Robert Mapplethorpe

Brian Ridley and Lyle Heeter, 1979
Silver print
20 × 16
Collection the estate of Robert Mapplethorpe

Bobby and Larry Kissing, 1979
Silver print
20 × 16
Collection the estate of Robert Mapplethorpe

Leigh Lee, 1980
Silver print
30 × 30
Courtesy G. H. Dalsheimer Gallery, Baltimore

Ron Simms, 1980
Silver print
20 × 16
Collection the estate of Robert Mapplethorpe

Dan S., 1980
Silver print
40 × 30
Collection Lynn Hurst, Houston, and John Van Alstine, Jersey City

Man in Polyester Suit, 1980
Silver print
20 × 16
Collection the estate of Robert Mapplethorpe

Z Portfolio, 1981
Alistair Butler, N.Y.C., 1980
Philip Prioleau, N.Y.C., 1979
Charles Edward Bowman, N.Y.C., 1980
Dennis Speight, N.Y.C., 1980
Dennis Speight, N.Y.C., 1980
Untitled, N.Y.C., 1981
Leigh Lee, N.Y.C., 1980
Bruce Thompson, San Francisco, 1980
Untitled, N.Y.C., 1980
Untitled, N.Y.C., 1981
Untitled, N.Y.C., 1981
Bob Love, N.Y.C., 1979
Daniel, N.Y.C., 1981
13 silver prints mounted on board
Each 13½ × 13½
Collection the estate of Robert Mapplethorpe

Ajitto, 1981
Silver print
40 × 30
Collection Harry H. Lunn, Jr., New York

Ajitto, 1981
Silver print
40 × 30
Collection Lois and Bruce Berry, Chicago

Ajitto, 1981
Silver print
40 × 30
Collection the estate of Robert Mapplethorpe

Ajitto, 1981
Silver print
40 × 30
Collection the Israel Museum, Jerusalem

Embrace, 1982
Silver print
20 × 16
Collection the estate of Robert Mapplethorpe

Derrick Cross, 1982
Silver print
19¾ × 43¼
Collection Anne and Joel Ehrenkranz, New York

Ada, 1982
Silver print
40 × 30
Collection the estate of Robert Mapplethorpe

Dennis Speight with Calla Lilies, 1983
Cibachrome print with mat
Overall 27 × 27
Collection the estate of Robert Mapplethorpe

Ken Moody, 1984
Cibachrome print with mat
24 × 20
Collection the estate of Robert Mapplethorpe

Ken Moody, 1984
Color Polaroid
24 × 20
Collection the estate of Robert Mapplethorpe

Ken Moody and Robert Sherman, 1984
Platinum print
25½ × 22
Collection the estate of Robert Mapplethorpe

Ken and Tyler, 1985
Platinum print
25½ × 22
Collection the estate of Robert Mapplethorpe

Bill T. Jones, 1985
Platinum print
25 × 22½
Collection Sondra Gilman and Celso Gonzalez-Falla,
 New York

Roedel Middleton, 1986
Silver print
24 × 20
Collection the estate of Robert Mapplethorpe

Thomas on a Pedestal, 1986
Silver print
40 × 30
Collection the estate of Robert Mapplethorpe

Thomas and Dovanna, 1986
Platinum emulsion on linen with silk
Overall 29½ × 48
Collection the estate of Robert Mapplethorpe

Thomas in Circle, 1987
Platinum emulsion on linen with fabric
Overall 51 × 26
Collection the estate of Robert Mapplethorpe

Chest, 1987
3 silver prints and frame
Overall 40 × 40
Collection Emily Fisher Landau, Rye, New York

Lydia Cheng, 1987
Silver print
20 × 24
Collection the estate of Robert Mapplethorpe

Lydia Cheng, 1987
Platinum emulsion on linen with silk
Frame 29½ × 45½
Private collection

Negro Bust, 1988
Silver print
24 × 20
Collection the estate of Robert Mapplethorpe

LISA LYON

Lisa Lyon, 1980
Silver print
20 × 16
Collection the estate of Robert Mapplethorpe

Lisa Lyon, 1980
Silver print
20 × 16
Collection the estate of Robert Mapplethorpe

Lisa Lyon, 1981
Silver print with mirror
20 × 16
Collection the estate of Robert Mapplethorpe

Lisa Lyon, 1982
Silver print
20 × 16
Collection the estate of Robert Mapplethorpe

Lisa Lyon, 1982
Silver print
20 × 16
Collection the estate of Robert Mapplethorpe

Lisa Lyon, 1982
Silver print
20 × 16
Collection the estate of Robert Mapplethorpe

Lisa Lyon, 1982
Silver print
20 × 16
Collection the estate of Robert Mapplethorpe

Lisa Lyon, 1982
Silver print
20 × 16
Collection the estate of Robert Mapplethorpe

PORTRAITS

Patti Smith, 1972
Black-and-white Polaroid with mat
Image 4 × 3¼, overall 11 × 9¾
Collection the estate of Robert Mapplethorpe

Patti Smith, Don't Touch Here, 1973
4 black-and-white Polaroids with found text in plastic mounts
Each image 4 × 3¼, overall 5½ × 18¾
Collection the estate of Robert Mapplethorpe

Archbishop of Canterbury Ramsey, 1975
Dye transfer print
20 × 16
Collection John D. Abbott, Jr., New York

Patti Smith, 1975
2 silver prints
Each image 13 × 13, overall 25 × 39½
Collection the estate of Robert Mapplethorpe

Patti Smith, 1976
Silver print
20 × 16
Collection the estate of Robert Mapplethorpe

Honey, 1976
Silver print
20 × 16
Collection the estate of Robert Mapplethorpe

Patti Smith, 1976
Silver print
26¼ × 21⅞
Collection the estate of Robert Mapplethorpe

Princess Diane de Beauveau, N.Y., 1976
2 silver prints
Each image 14 × 14, overall 39 × 25
Collection the estate of Robert Mapplethorpe

David Hockney and Henry Geldzahler, 1976
Silver print
20 × 16
Collection the estate of Robert Mapplethorpe

Jesse McBride, 1976
Silver print
13¾ × 13¾
Collection the estate of Robert Mapplethorpe

Downtown Art Dealers, 1978
11 silver prints with frame
Overall 91 × 15
Collection the estate of Robert Mapplethorpe

Patti Smith, 1979
Silver print
30 × 30
Collection the estate of Robert Mapplethorpe

Phyllis Tweel, 1979
Silver print
20 × 16
Collection the estate of Robert Mapplethorpe

James Ford, 1979
Silver print
30 × 30
Collection the estate of Robert Mapplethorpe

Carolina Herrera, 1979
Silver print with mirrors and frame
Image 17¾ × 13¾, overall 29½ × 26½
Collection the estate of Robert Mapplethorpe

Katherine Cebrian, 1980
Silver print
30 × 30
Collection the estate of Robert Mapplethorpe

William Burroughs, 1980
Silver print
20 × 16
Collection the estate of Robert Mapplethorpe

Miep Brons, 1980
Silver print
20 × 16
Collection the estate of Robert Mapplethorpe

Smutty, 1980
Silver print
20 × 16
Collection the estate of Robert Mapplethorpe

Leo Castelli, 1982
Silver print
20 × 16
Collection the estate of Robert Mapplethorpe

Louise Bourgeois, 1983
Silver print
20 × 16
Collection the estate of Robert Mapplethorpe

Doris Saatchi, 1983
Platinum print
25 × 22½
Collection the estate of Robert Mapplethorpe

Donald Sutherland, 1983
Silver print
20 × 16
Collection the estate of Robert Mapplethorpe

Sam Wagstaff, 1983
Silver print
20 × 16
Collection the estate of Robert Mapplethorpe

Cindy Sherman, 1983
Silver print
20 × 16
Collection the estate of Robert Mapplethorpe

Lucinda's Hands, 1985
Cibachrome print
24 × 20
Collection the estate of Robert Mapplethorpe

Francesco Clemente, 1985
Platinum print
25½ × 22
Collection the estate of Robert Mapplethorpe

Andy Warhol, 1986
Platinum emulsion on linen with silk and shaped frame
Overall 43 × 42
Collection George and Betsy Frampton, Washington, D.C.

Louise Nevelson, 1986
Silver print
24 × 20
Collection the estate of Robert Mapplethorpe

Patti Smith, 1986
Platinum emulsion on linen with velvet
Overall 42 × 38
Collection George Dalsheimer, Baltimore

Laurie Anderson, 1987
Silver print
24 × 20
Collection the estate of Robert Mapplethorpe

Suzanne Donaldson, 1987
Silver print
24 × 20
Collection the estate of Robert Mapplethorpe

Lucy Ferry, 1987
Platinum emulsion on linen with silk
Overall 29½ × 50
Collection Mr. and Mrs. Harold A. Honickman, Rydal, Pennsylvania

Andy Warhol, 1987
Silver print
24 × 20
Collection the estate of Robert Mapplethorpe

SELF-PORTRAITS

Self-Portrait, 1974
Silver print with shaped frame
14½ × 23¼
Collection the estate of Robert Mapplethorpe

Dancer, 1974
2 black-and-white Polaroids
Each 4½ × 3½, overall 8 × 18
Collection the estate of Robert Mapplethorpe

Self-Portrait, 1980
Silver print
20 × 16
Collection the estate of Robert Mapplethorpe

Self-Portrait, 1980
Silver print
20 × 16
Collection the estate of Robert Mapplethorpe

Self-Portrait, N.Y.C., 1980
Silver print
20 × 16
Collection the estate of Robert Mapplethorpe

Self-Portrait, 1983
Silver print
20 × 16
Collection the estate of Robert Mapplethorpe

Self-Portrait, 1985
Platinum print
25½ × 22
Collection the estate of Robert Mapplethorpe

Self-Portrait, 1985
Silver print
20 × 16
Collection the estate of Robert Mapplethorpe

Self-Portrait, 1986
Silver print
24 × 20
Collection the estate of Robert Mapplethorpe

Self-Portrait, 1988
Silver print
24 × 20
Collection the estate of Robert Mapplethorpe

OBJECTS

Tie Rack, 1969
Mixed media with found lithograph
24 × 18 × 4½
Collection the estate of Robert Mapplethorpe

Cowboy, 1970
Mixed media
12 × 15
Collection the estate of Robert Mapplethorpe

Heart and Dagger, 1982
2 parts, each with found dagger and cloth in shaped frame
Each 15 × 15½
Collection the estate of Robert Mapplethorpe

Untitled, 1983
Felt in shaped frame
37 × 36
Collection the estate of Robert Mapplethorpe

Star, 1983
Mirrored glass in shaped frame
49 × 49
Collection Dimitri Levas, New York

Black X, 1983
Glass in shaped frame
45 × 45
Collection the estate of Robert Mapplethorpe

EXHIBITION HISTORY
COMPILED BY ANDREW O. ROBB

SELECTED ONE-PERSON EXHIBITIONS

Robert Mapplethorpe was born November 4, 1946, in Floral Park, New York. He received his B.F.A. from Pratt Institute, Brooklyn, New York, in 1970. He died on March 9, 1989.

1976
"Polaroids," Light Gallery, New York.

1977
"Flowers," Holly Solomon Gallery, New York.

"Erotic Pictures," The Kitchen, New York.

"Portraits," Holly Solomon Gallery, New York.

1978
"Film and Stills," Robert Miller Gallery, New York.

Chrysler Museum, Norfolk, Virginia. Catalogue with text by Mario Amaya.

Langdon Street Gallery, San Francisco.

Simon Lowinsky Gallery, San Francisco.

La Remise du Parc Gallery, Paris.

Los Angeles Institute of Contemporary Art, Los Angeles.

Corcoran Gallery of Art, Washington, D.C.

1979
"Robert Mapplethorpe: 1970–75," Robert Samuel Gallery, New York.

"Contact," Robert Miller Gallery, New York.

Galerie Jurka, Amsterdam. Catalogue with text by Rein von der Fuhr.

Texas Gallery, Houston.

"Trade Off" (with Lynn Davis), International Center of Photography, New York.

1980
"Black Males," Galerie Jurka, Amsterdam. Catalogue with text by Edmund White.

Vision Gallery, Boston.

"Robert Mapplethorpe: Blacks and Whites," Lawson/DeCelle Gallery, San Francisco.

In a Plain Brown Wrapper Gallery, Chicago.

Stuart Gallery, Chicago.

Contretype Gallery, Brussels.

Van Reekum Museum, Apeldoorn, Netherlands.

Fraenkel Gallery, San Francisco.

1981
Lunn Gallery, Washington, D.C.

Robert Miller Gallery, New York.

"Robert Mapplethorpe," Kunstverein, Frankfurt am Main. Traveled to Fotogalerie Forum Stadtpark, Graz, Austria; Modern Art Galerie, Vienna; PPS Galerie F.C. Gundlach, Hamburg; Kunsthalle, Basel; Kunstverein, Munich; and Nikon Foto Galerie, Zurich. Catalogue with text by Sam Wagstaff and Peter Weiermair.

Contretype Gallery, Brussels.

Galerie Texbraun, Paris.

Fraenkel Gallery, San Francisco.

Robert Miller Gallery, New York.

Nagel Gallery, Berlin.

"Recent Photographs," ACE Gallery, Los Angeles.

"ART 12 '81," Galeria Jurka, Basel.

1982
"Black Males," Galleria il Ponte, Rome.

"Robert Mapplethorpe's Fotos," Galerie Tom Peek, Utrecht, Netherlands.

Larry Gagosian Gallery, Los Angeles.

"Recent Work," Galerie Jurka, Amsterdam.

Contemporary Arts Center, New Orleans.

Fay Gold Gallery, Atlanta.

Young Hoffman Gallery, Chicago.

Shore Gallery, The Pines, Long Island, New York.

Galerie Watari, Tokyo.

1983
"New Works," Robert Miller Gallery, New York.

"Recent Work," Hardison Fine Arts Gallery, New York.

"Lady, Lisa Lyon," Leo Castelli Gallery, New York.

Centre National d'Art et de Culture Georges Pompidou, Paris.

"Lady, Lisa Lyon," Olympus Centre, London.

"Robert Mapplethorpe Flowers," Galerie Watari, Tokyo. Catalogue with text by Sam Wagstaff.

"Robert Mapplethorpe, 1970–1983," Institute of Contemporary Arts, London. Traveled to Stills, Edinburgh; Arnolfini, Bristol; Midland Group, Nottingham; and Museum of Modern Art, Oxford. Catalogue with text by Stuart Morgan and Alan Hollinghurst.

Jane Corkin Gallery, Toronto.

"Lady," Rüdiger Schöttle Galerie, Munich.

"Lady, Lisa Lyon," Photografie Galerie, Düsseldorf.

"Photogravures—1983," Barbara Gladstone Gallery, New York.

"Robert Mapplethorpe Fotografie," Centro di Documentazione di Palazzo Fortuny, Venice. Traveled to Palazzo delle Cento Finestre, Florence. Catalogue with text by Germano Celant.

"The Agency," Hardison Fine Arts Gallery, New York. Catalogue.

1984
"Robert Mapplethorpe Fotografías, 1970–1983," Galeria Fernando Vijande, Madrid.

"Process," Barbara Gladstone Gallery, New York.

"Robert Mapplethorpe: Photographies, 1978–1984," John A. Schweitzer, Montreal.

"Lady," Hara Museum of Contemporary Art, Tokyo. Catalogue.

"Matrix 80," Wadsworth Atheneum, Hartford.

1985
Galerie Daniel Templon, Paris.

"Black Flowers," Galeria Cómicos, Lisbon.

"New Works in Platinum," Robert Miller Gallery, New York.

Betsy Rosenfield Gallery, Chicago.

Fay Gold Gallery, Atlanta.

Michael Lord Gallery, Milwaukee.

"Recent Works in Platinum," Fraenkel Gallery, San Francisco.

1986
"Robert Mapplethorpe: Photographs 1976–1985," Australian Center for Contemporary Art, South Yarra, Victoria. Catalogue with text by Paul Foss.

Betsy Rosenfield Gallery, Chicago.

Texas Gallery, Houston.

"New Photographs," Palladium, New York.

1987
Robert Miller Gallery, New York.

Julia Gallery, New Orleans.

"Robert Mapplethorpe 1986," Raab Galerie, Berlin; Kicken-Pauseback, Cologne. Catalogue with interview by Anne Horton.

Fraenkel Gallery, San Francisco.

Obalne Galerije, Piran, Yugoslavia. Catalogue with text by Germano Celant.

Galerie Pierre-Hubert, Geneva.

Galerie Françoise Lambert, Milan.

1988
"Robert Mapplethorpe," Stedelijk Museum, Amsterdam. Catalogue with text by Els Barents.

"Mapplethorpe Portraits," National Portrait Gallery, London. Catalogue with text by Peter Conrad.

"Robert Mapplethorpe: The Perfect Moment," Institute of Contemporary Art, University of Pennsylvania, Philadelphia. Catalogue with text by Janet Kardon, David Joselit, Kay Larson, and Patti Smith. Traveled to Museum of Contemporary Art, Chicago; Washington Project for the Arts, Washington, D.C.; Wadsworth Atheneum, Hartford; University Art Museum, University of California, Berkeley; Contemporary Arts Center, Cincinnati; and Institute of Contemporary Art, Boston.

Whitney Museum of American Art, New York. Catalogue with text by Richard Marshall, et al.

"Photographien" (with Thomas Ruff), Mai 36 Galerie, Lucerne.

Robert Miller Gallery, New York.

Hamiltons Gallery, London.

Galerie Jurka, Amsterdam.

SELECTED GROUP EXHIBITIONS

1973
"Polaroids: Robert Mapplethorpe, Brigid Polk, Andy Warhol," Gotham Book Mart, New York.

1974
"Recent Religious and Ritual Art," Buecker and Harpsichords, New York.

"Group Exhibition," Bykert Gallery, New York.

1976
"Animals," Holly Solomon Gallery, New York.

1977
documenta 6, Kassel, West Germany. Catalogue with text by Manfred Schneckenburger.

1978
"The Collection of Sam Wagstaff," Corcoran Gallery of Art, Washington, D.C. Traveled to St. Louis Art Museum, Missouri; Grey Art Gallery and Study Center, New York University, New York; Seattle Art Museum, Washington; University Art Museum, University of California, Berkeley; and High Museum, Atlanta. Checklist by Jane Livingston.

"Mirrors and Windows: American Photography Since 1960," Museum of Modern Art, New York. Traveled to Cleveland Museum of Art, Ohio; Walker Art Center, Minneapolis; J. B. Speed Museum, Louisville, Kentucky; Museum of Modern Art, San Francisco; Krannert Art Museum, University of Illinois, Champaign; Virginia Museum of Fine Arts, Richmond; and Milwaukee Art Center. Catalogue with text by John Szarkowski.

"Rated X," Marge Neikrug Gallery, New York.

1979
"People Watching," Museum of Modern Art, Art Advisory Service, New York.

"Attitudes," Santa Barbara Museum of Art, Santa Barbara, California. Catalogue with text by Fred Parker.

"Artists by Artists," Whitney Museum of American Art Downtown, New York.

"American Portraits of the Sixties and Seventies," Aspen Center for the Visual Arts, Aspen, Colorado. Catalogue with text by Julie Augur.

1980
"Secret Paintings (Erotic Paintings and Photographs)," Jehu Gallery, San Francisco.

"Presences: The Figure and Manmade Environments," Freedman Gallery, Albright College, Reading, Pennsylvania. Catalogue with text by Bruce Sheftel.

"In Photography, Color As Subject," School of Visual Arts Museum, New York.

"Quattro Fotografi Differenti," Padiglione d'Arte Contemporanea, Milan. Catalogue by Carol Squiers.

"New Visions," Carson-Sapiro Gallery, Denver.

"The Norman Fisher Collection," Jacksonville Art Museum, Jacksonville, Florida. Catalogue with text by Ted Castle, et al.

1981
"Marked Photographs," Robert Samuel Gallery, New York.

"Autoportraits Photographiques," Centre National d'Art et de Culture Georges Pompidou, Paris.

"New York, New Wave," Institute for Art and Urban Resources, P.S. 1, Long Island City, New York.

"Land/Urban Scapes," Islip Town Center, Islip, New York. Checklist with text by Jeanette Ingberman.

"Inside Out—Self Beyond Likeness," Newport Harbor Art Museum, Newport Beach, California. Traveled to Portland Art Museum, Oregon, and Joslyn Art Museum, Omaha, Nebraska. Catalogue with text by Lynn Gamwell.

1981 Biennial Exhibition, Whitney Museum of American Art, New York. Catalogue.

"Figures: Forms and Expressions," Albright-Knox Art Gallery, Buffalo. Catalogue with text by Robert Collingnon and Biff Henrich.

"US Art Now," Nordiska Kompaniet, Stockholm; Gotesborgs Kunstmuseum, Gotesborg. Catalogue with text by Lars Peder Hedberg.

"Surrealist Photographic Portraits: 1920–1980," Marlborough Gallery, New York. Catalogue with text by Dennis Longwell.

"Instant Fotografie," Stedelijk Museum, Amsterdam. Catalogue with text by Els Barents in collaboration with Karel Schampers.

1982
"Counterparts: Form and Emotion in Photographs," Metropolitan Museum of Art, New York. Catalogue with text by Weston J. Naef.

"The Black Male Image," Harlem Exhibition Space, New York.

"Faces Photographed," Grey Art Gallery and Study Center, New York University, New York. Catalogue with text by Ben Lifson.

"Points of View," Museum of Art, University of Oklahoma, Norman. Catalogue with text by Sam Olkinetzky.

documenta 7, Kassel, West Germany. Catalogue with text by Rudi Fuchs.

"La Photographique en Amérique," Galerie Texbraun, Paris.

"Lichtbildnisse," Rheinisches Landesmuseum, Bonn.

"The Erotic Impulse," Concord Gallery, New York.

"Portraits," Concord Gallery, New York.

"Intimate Architecture: Contemporary Clothing Design," Hayden Gallery, List Visual Arts Center, Massachusetts Institute of Technology, Cambridge. Catalogue with text by Susan Sidlauskas.

1983
Photografie Galerie, Düsseldorf.

"Three-Dimensional Photographs," Castelli Graphics, New York.

"Presentation: Recent Portrait Photography," Taft Museum, Cincinnati. Catalogue with text by Janet Borden.

"Phototypes," Whitney Museum of American Art Downtown, New York. Checklist with text by Philip Hotchkiss Walsh, et al.

"Drawings, Photographs," Leo Castelli Gallery, New York.

"Self-Portraits," Linda Farris Gallery, Seattle; Los Angeles Municipal Art Gallery. Catalogue with text by Peter Frank.

"Photography in America 1910–1983," Tampa Museum, Florida. Catalogue with text by Julie M. Saul.

"New Art," Tate Gallery, London.

"New Perspectives on the Nude," The Foto Gallery, Wales.

1984
"Investigations 10, Face to Face: Recent Portrait Photography," Institute of Contemporary Art, University of Pennsylvania, Philadelphia. Catalogue with text by Paula Marincola.

"Twelve on 20 × 24," organized by New England Foundation for the Arts, Cambridge. Traveled to Gallery of the School of Fine Arts, Boston; Westbrook College, Portland, Maine; Fitchburg Art Museum, Fitchburg, Massachusetts; Smith College Museum, Northampton, Massachusetts; and Honolulu Academy of Arts, Hawaii. Catalogue with text by Jon Holmes.

"Flower As Image in 20th-Century Photography," Wave Hill, Bronx, New York. Catalogue with text by Linda Macklowe.

"Terrae Motus," Foundazione Amelio, Naples. Catalogue with text by Giulio Carlo Argan, et al.

"Radical Photography: The Bizarre Image," Nexus Gallery, Atlanta. Catalogue with text by Eric D. Bookhardt.

"Portrait Photography," Delahunty Gallery, Dallas.

"Sex," Cable, New York.

"Sex-Specific: Photographic Investigations of Contemporary Sexuality," School of the Art Institute of Chicago, Superior Street Gallery, Chicago. Catalogue with text by Joyce Fernandes.

"Still-Life Photographs," Jason McCoy Inc., New York.

"Allegories of the Human Form: A Photography Exhibit," Dowd Fine Arts Center Gallery, State University of New York, Cortland.

"The Heroic Figure," Contemporary Arts Museum, Houston. Traveled to Memphis Brooks Museum of Art, Tennessee; Alexandria Museum/Visual Art Center, Alexandria, Louisiana; and Santa Barbara Museum of Art, Santa Barbara, California. Catalogue with text by Linda Cathcart and Craig Owens.

"Second Salon of Montreal Art Galleries," Palais des Congrès, Montreal.

1985
"Five Years with 'The Face,'" Photographers' Gallery, London.

"Image, Insight: Photographic Intuitions of the 1980s," Islip Art Museum, East Islip, New York.

"Nude, Naked, Stripped," Hayden Gallery, List Visual Arts Center, Massachusetts Institute of Technology, Cambridge. Catalogue with text by Carrie Rickey.

"Beautiful Photographs," One Penn Plaza, New York.

"The New Figure," Birmingham Museum of Art, Alabama.

"Messages from 1985," Light Gallery, New York.

"Picture-Taking: Weegee, Walker Evans, Sherrie Levine, Robert Mapplethorpe," Mary and Leigh Block Gallery, Northwestern University, Evanston, Illinois. Catalogue with text by William Olander.

"Entertainment," Josh Baer Gallery, New York.

"Flowers: Varied Perspectives," Patricia Heesy Gallery, New York.

"Beauty," Palladium, New York.

"Big Portraits," Jeffrey Hoffeld & Co., New York.

Fraenkel Gallery, San Francisco.

"Self-Portrait: The Photographer's Persona 1840–1985," Museum of Modern Art, New York.

"Home Work," Holly Solomon Gallery, New York.

1986
"OSO Bay Biennial," Corpus Christi State University, Texas.

"Rules of the Game: Culture Defining Gender," Mead Art Museum, Amherst College, Amherst, Massachusetts. Catalogue with text by Judith Barter and Anne Mochon.

Edwynn Houk Gallery, Chicago.

"intimate/INTIMATE," Turman Gallery, Indiana State University, Terre Haute. Catalogue with text by Charles S. Mayer and Bert Brouwer.

"Sacred Images in Secular Art," Whitney Museum of American Art Downtown, New York.

Bentler Galleries Inc., Houston.

"A Matter of Scale," Rockland Center for the Arts and Blue Hill Plaza Associates, Pearl River, New York.

"Contemporary Issues III," Holman Hall Art Gallery, Trenton State College, New Jersey. Catalogue with text by Lois Fichner-Rathus.

"The Sacred and the Sacreligious: Iconographic Images in Photography," Photo Resource Center, Boston.

"Invitation: La Revue Parkett," Centre National d'Art et de Culture Georges Pompidou, Paris.

"Midtown Review," International Center of Photography/Midtown, New York.

"Staging the Self," National Portrait Gallery and Plymouth Arts Centre, London.

"Art & Advertising, Commercial Photography by Artists," International Center of Photography, New York. Catalogue with text by Willis Hartshorn.

"The Fashionable Image: Unconventional Fashion Photography," Mint Museum, Charlotte, North Carolina. Catalogue with text by Henry Barendse.

1987
"Portrait: Faces of the '80s," Virginia Museum of Fine Arts, Richmond. Catalogue with text by George Cruger.

"Il Nudo Maschile Nella Fotografia 19th–20th c.," Commune di Ravenna, Ravenna, Italy.

"Legacy of Light," International Center of Photography, New York.

"Of People and Places: The Floyd and Josephine Segal Collection of Photography," Milwaukee Art Museum. Catalogue with text by Verna Posever Curtis.

1988
"First Person Singular: Self-Portrait Photography, 1840–1987," High Museum at Georgia-Pacific Center, Atlanta. Catalogue with text by Ellen Dugan.

"Fotofest 88," Houston.

"Return of the Hero," Burden Gallery, Aperture Foundation, New York.

"Flowers," Grand Rapids Museum, Michigan.

"LifeLike," Lorence-Monk Gallery, New York.

Barbara Gladstone Gallery, New York.

SELECTED BIBLIOGRAPHY
COMPILED BY ANDREW O. ROBB

SELECTED PROJECTS AND BOOKS BY THE ARTIST

"Mixed Media (I)." *Unmuzzled Ox*, no. 4 (1976): 12.

still moving/patti smith. Black-and-white film directed by the artist, 1978.

With Joseph Kosuth, Lawrence Weiner, and Kathy Acker. "Portraits . . ." *Artforum* (May 1982): 58–69.

"Cinq Photographies." *Cahiers de l'Energumene*, no. 2 (1983): 29–36.

With text by Bruce Chatwin, foreword by Sam Wagstaff. *Lady, Lisa Lyon*. New York: Viking Press, 1983.

The Agency. New York: Hardison Fine Arts Gallery, 1983.

Lady, Lisa Lyon. Color film directed by the artist, 1984.

With Susan Sontag. *Certain People: A Book of Portraits*. Pasadena, California: Twelvetrees Press, 1985.

"Heads and Flowers." *The Paris Review* (Spring 1985):27–35.

"Robert Mapplethorpe." *Photo/Design* (August 1985): 44.

Curator with Laurie Simmons. "Split Vision." Artists Space, New York, 1985.

Black Flowers. Madrid: Fernando Vijande Galeria, 1985.

"Robert Mapplethorpe." *Parkett 8* (1986): 109–21.

With Paul Schmidt. *Arthur Rimbaud: A Season in Hell*. New York: Limited Editions Club, 1986.

With text by Richard Marshall. *50 New York Artists*. San Francisco: Chronicle Press, 1986.

With Jan Fabre. *The Power of Theatrical Madness*. London: Institute of Contemporary Arts, 1986.

With Lucinda Childs. *Portraits in Reflection*. Dance project, Joyce Theater, New York, 1986.

With foreword by Ntozake Shange. *Black Book*. New York: St. Martin's Press, 1986.

"Fashion Studies in Black and White." *Interview* (March 1987).

Introduction by Ikuroh Takano, interview by David Hershkovits. *Robert Mapplethorpe*. Tokyo: Parco Co., 1987.

With text by Els Barents. *Ten by Ten*. Munich: Schirmer/Mosel, 1988.

SELECTED ARTICLES AND REVIEWS

Albright, T. "The World of Decadent Chic." *San Francisco Chronicle* (1 May 1980).

Anderson, Alexandra. "The Collectors." *Vogue* (March 1985): 304–6.

Andre, Michael. "'Recent Religious and Ritual Art' (Buecker and Harpsichords): Robert Mapplethorpe, Lenny Salem, and Royce Dendler." *Art News* (March 1974): 107.

Aronson, Steven M. L. "Reflections in a Photographer's Eye." *House and Garden* (May 1986): 84–87.

Artner, Alan G. "'Sex Specific' Exhibit Is Tiring in Its Unoriginality." *Chicago Tribune* (16 November 1984): 7.6.

Auer, James. "Intimate Images." *The Milwaukee Journal* (16 June 1985): 16–18.

Bahrens, P. "Photos im Zwiespalt." *Rhemische Post* (16 April 1983).

Bas Roodnat, D. "Mapplethorpe's Foto's Met Onderkoelde 'Power.'" *NCR Handelsblad* (Germany) (23 May 1979).

Berg, Andre. "Lisa Lyon: Instantes Muscles par Robert Mapplethorpe." *Photo* (France), no. 188, 83–84.

Boettger, S. "Black and White Leather." *The Daily Californian* (11 April 1980).

Bondi, I. "The Yin and Yang of Robert Mapplethorpe." Interview. *Print Letter* (Switzerland) (January–February 1981): 9–11.

Bonney, Claire. "The Nude Photograph: Some Female Perspectives." *Women's Art Journal* (Fall/Winter 1985–86): 13.

Bourdon, David. "Robert Mapplethorpe." *Arts Magazine* (April 1977): 7.

Bulgari, Elsa. "Robert Mapplethorpe." Interview. *Fire Island Newsmagazine* (3 July 1978): 22.

Burg, Lester. "Blatantly Subtle." *Gaysweek* (23 April 1979): 8.

———. "The Art of Being Gay." *Gaysweek* (24 June 1979): 22.

Burnett, W. C. "Ex-Painter Gets in Focus with Camera." *The Atlanta Journal* (2 April 1982).

Bush, Catherine. "Still Life in Motion." *Theatre Crafts* (February 1987): 32–33.

Butler, Susan. "Revising Femininity." *Creative Camera* (September 1983): 1090–93.

Catalano, Gary. "Pictures of Sculpture Vision." *The Age* (Australia) (12 February 1986): 14.

Caujolle, C. "Une Photographie Tres Musclée." *Liberation* (France) (29 April 1983).

———. "Robert Mapplethorpe: Black, White and Square." *Beaux Arts Magazine* (France) (November 1983): 64–69.

Celant, Germano. "Entrevista con Mapplethorpe." Interview. *Vardar* (Spain) (May 1984): 20–23.

———. "Gli Inferi Fotografici." *Tema Celeste* (Italy) (October 1984).

———. "Los Inferos Fotograficos: Mapplethorpe y Witkin." *La Gaceta del Libro* (Spain) (February 1985): 10–11.

———. "The Infernal Divinities of Photography in Mapplethorpe and Witkin." *Art Press* (France) (February 1985): 4–8.

Champeau, Albert. "Robert Mapplethorpe." *Creatis: La photographie au present* (France), no. 7 (1978).

Chatwin, Bruce. "Body Building Beautiful." *Sunday Times Magazine* (Great Britain) (17 April 1983): 4.

———, and Donald Richards. "Strong Stuff: Lisa Lyon's Body Beautiful." *Tatler* (Great Britain) (June 1983).

Coumans, W. K. "Robert Mapplethorpe." *Foto* (August 1979).

Coupland, Ken. "Robert Mapplethorpe." *Sentinel USA* (23 May 1985): 12.

Danto, Arthur C. "Robert Mapplethorpe." *The Nation* (26 September 1988): 246–50.

Davis, Douglas. "The Return of the Nude." *Newsweek* (1 September 1986): 79.

del Pozzo, S. "Che Forza Quell'artista." *Panorama* (Italy) (14 March 1983).

Dills, Keith. *Artweek* (18 May 1985): 20.

Donkers, Jan. "Fotograaf Robert Mapplethorpe." Interview. *A Avenue* (Netherlands) (January 1984): 81–84.

Ellenzweig, Allen. "The Homosexual Aesthetic." *American Photographer* (August 1980): 60–63.

———. "Robert Mapplethorpe at Robert Miller." *Art in America* (November 1981): 171–72.

Evans, Tom. "Photographer in Focus." *Art and Artists* (Great Britain) (March 1984): 16–19.

Everly, Bart. "Robert Mapplethorpe." Interview. *Splash* (April 1988).

"'Explicit' Photo of Homosexuals Raises Eyebrows." *Daily Telegraph* (Great Britain) (January 1984).

Filler, Martin. "Robert Mapplethorpe." *House and Garden* (June 1988): 158–63.

Fischer, H. "Calculated Opulence: Robert Mapplethorpe." *Artweek* (21 November 1980).

Flood, Richard. "Skied and Grounded in Queens: New York/New Wave at P.S. 1." *Artforum* (Summer 1981): 84–87.

Foster, Hal. "Robert Mapplethorpe, Holly Solomon Gallery." *Artforum* (February 1978): 67–69.

Friedman, Jon R. "Robert Mapplethorpe." *Arts Magazine* (June 1979): 32.

Goldberg, Vicki. "The Art of Salesmanship: Photography As a Tool of Advertising." *American Photographer* (February 1987): 28.

Green, Janina. "Seductive Style, Chiseled Technique . . . and Too Beautiful." *The Melbourne Times* (Australia) (12 February 1986): 8.

Green, Roger. "Dureau and Mapplethorpe: Two Points of View." *The New Orleans Times-Picayune* (3 January 1982).

———. "Softening a Sexy Image with Flowers." *Lagniappe* (30 January 1987).

Grundberg, Andy. "Is Mapplethorpe Only Out To Shock?" *The New York Times* (13 March 1983): 2.32.

———. "Certain People." Review. *The New York Times Book Review* (8 December 1985): 22.

———. "The Mix of Art and Commerce." *The New York Times* (28 September 1986): 2.1.

———. "Prints That Go Beyond the Border of the Medium." *The New York Times* (3 May 1987): 2.29.

———. "Portraits in a New Perspective." *The New York Times* (26 June 1988): 2.31.

Haenlein, C. "Robert Mapplethorpe Photographien 1970–83." *Du: Die Kunstzeitschrift* (Germany) (1984): 10–13.

Hagen, Charles. "'Art and Advertising: Commercial Photography by Artists.'" *Artforum* (November 1986): 136–37.

Handy, Ellen. "Robert Mapplethorpe/Hollis Sigler." *Arts Magazine* (December 1983): 38–39.

Hayes, Robert. "Robert Mapplethorpe." Interview. *Interview* (March 1983): 50–54.

Henry, Gerrit. "Outlandish Nature." *Art News* (April 1977): 118.

———. "Robert Mapplethorpe—Collecting Quality: An Interview." *The Print Collector's Newsletter* (September/October 1982): 128–30.

Hershkovits, David. "Shock of the Black and the Blue." *The SoHo News* (20 May 1981): 9–11.

Himmel, Eric. "Cut Flowers." *Camera Arts* (April 1983): 56–61.

Hodges, Parker. "Robert Mapplethorpe Photographer." *Manhattan Gaze* (10 December 1979).

Hullenkremer, Marie. "Spitzenpreise für alte Wolken und aggressive Porträts." *art* (Germany) (January 1984): 15.

"In Bloom: Photographs by Robert Mapplethorpe." *35 mm Photography* (Spring 1979): 94–105.

Indiana, Gary. "Mapplethorpe." *The Village Voice* (14 May 1985): 97.

———. "Robert Mapplethorpe." Interview. *Bomb* (Winter 1988): 18.

"Interview." *Photo Japon* (Japan) (November 1984): 53–59.

Januszczak, Waldemar. "A Fistful of Feminine Flattery." *The Guardian* (Great Britain) (27 June 1983): 18.

Jentz, T. "Robert Mapplethorpe: Restless Talent." *New York Photo* (April 1983).

Jordan, Jim. "A Decade of Diversity." *Artweek* (11 April 1987): 10.

Kissel, Howard. "Robert Mapplethorpe: Unsettling Images." *W* (14 July 1986): 22.

Kisselgoff, Anna. "Dance: Lucinda Childs Offers World Premiere." *The New York Times* (29 January 1986): C24.

Koch, Stephen. "Guilt, Grace and Robert Mapplethorpe." *Art in America* (November 1986): 144–51.

Koffman, P. "Zwarte Mannen, Gezien door Robert Mapplethorpe." *NCR Handelsblad* (Germany) (22 November 1980).

Kohn, Michael. "Robert Mapplethorpe." *Arts Magazine* (September 1982): 43.

Kolbowski, Silvia. "Covering Mapplethorpe's 'Lady.'" *Art in America* (Summer 1983): 10–11.

"The Lady Is a Lyon." *American Photographer* (October 1983): 85.

Larson, Kay. "Robert Mapplethorpe at Robert Miller." *New York* (7 June 1981): 57–58.

———. "Between a Rock and a Soft Place." *New York* (1 June 1981): 56–58.

———. "How Should Artists Be Educated?" *Art News* (November 1983): 85–91.

———. "Getting Graphic." *New York* (15 August 1988): 66–67.

Laude, A. "Creats." *Les Nouvelles Littéraires* (France) (15 December 1978).

"Der Ledermann Stehr Modell." *Leverkusener* (Germany) (6 May 1981).

Lee, D. "Robert Mapplethorpe." *Arts Review* (9 December 1983): 84.

Leonhart, M. Michael. "Photographer Evokes Precise Portrait Statements." *Gay Life* (29 February 1975).

"Letter from Japan." *Art and Auction* (November 1984).

Levy, Mark. "Robert Mapplethorpe at Fraenkel Gallery." *Images and Issues* (Spring 1982): 77–78.

Lifson, Ben. "Games Photographers Play." *The Village Voice* (2 April 1979): 80.

———. "Philistine Photographer: Reassessing Mapplethorpe." *The Village Voice* (9 April 1979): 79.

Lifton, Norma. "Picture-Taking." *New Art Examiner* (February 1986): 56.

Llopis, Silvia. "El Sexo es el Mensaje." *Cambio 16* (Spain) (3 May 1984): 110–12.

Lucie-Smith, Edward. "The Gay Seventies?" *Art and Artists* (December 1979): 4–11.

———. "Robert Mapplethorpe." *Art and Artists* (November 1983): 15–16.

Lynch, Kevin. "Mapplethorpe's Art a Sensual Symphony in Black and White." *The Milwaukee Journal* (30 June 1985): Entertainment 10.

Lynne, Jill. "Interview." *Palace Magazine* (October 1981).

Lyon, Christopher. "Sex Hides Below Surface of Contemporary Photos." *Chicago Sun-Times* (16 November 1984): 3.

Manegold, C. S. "Robert Mapplethorpe, 1970–1983; on the 1983–1984 Retrospective." *Arts Magazine* (February 1984): 96–99.

———. "Robert Mapplethorpe: The Latest Wave." *Artscribe* (Great Britain) (February–April 1984): 36–40.

"Mapplethorpe Photographs Seek More Than Arousal." *Chicago Tribune* (29 February 1980).

"Mapplethorpe's Photography Collection Sold." *Maine Antique Digest* (August 1982).

"Mapplethorpe Goes Platinum." *Sentinel USA* (23 May 1985): 10–11.

Mari, Rafa. "En Botica." *Noticias* (Spain) (14 February 1984).

Marinas, J. Alberto. "Robert Mapplethorpe Expone en la Galeria Fernando Vijande." *Diorama, Fotografia, Cine, Sonido, y Video* (Spain) (April 1984): 3–15.

Matthies, Robert. "Lady, Lisa Lyon." Review. *Photographic Society of America Journal* (October 1983): 8.

McDonald, R. "Getting Off (Turning Off?)." *Leica Journal* (October/November 1978).

McKenzie, Barbara. "Robert Mapplethorpe." Interview. *Open City* (November 1985): 19–21.

Morch, Al. "It's More Than Parlor Decadence." *San Francisco Examiner* (27 November 1985): B12.

Morgan, Stuart. "Something Magic." *Artforum* (May 1987): 118–23.

———. "Mapplethorpe." *Cliches* (Belgium) (October 1987): 16–23.

Morrisroe, Patricia. "Prints of Darkness." *Sunday Times Magazine* (Great Britain) (30 October 1983): 81–85.

Muchnic, Suzanne. "Galleries: La Cienega Area." *Los Angeles Times* (9 July 1982): 6.11.

Nicol, G. "Ezfundene Schondert als Schutz." *Tannus* (Germany) (14 April 1981).

Novi, M. "Tutto il corpo di Lisa." *La Repubblica* (Spain) (10 April 1983).

Nurnberg, W. "Staging the Self." *British Journal of Photography* (Great Britain) (19 December 1986): 1450–52.

Pally, M. "Radiant Rebel." *New York Native* (28 March 1983).

Panicelli, Ida. "Robert Mapplethorpe, Palazzo delle Centro Finestre, Galleria Lucio Amelio." *Artforum* (October 1984): 98–99.

Peral, E. "Robert Mapplethorpe: Fotografias, 1970–1983." *Arte Fotografico* (Spain) (May 1984): 543–45.

Perrone, Jeff. "Robert Mapplethorpe: Robert Miller Gallery." *Artforum* (Summer 1979): 69–73.

Pinharanda, João. "Robert Mapplethorpe—O Exercício Dos Corpos." *Oglobo* (Portugal) (25 February 1984): 1.

Porter, Allan. "Transfiguration/Configuration: Mapplethorpe." *Camera* (Switzerland) (Summer 1977): 4–13.

Post, Henry. "Mapplethorpe's Camera Lusts for Exposing Sex Objects." *Gentlemen's Quarterly* (February 1982): 28.

Pousner, Howard. "Shoot First, Ask Questions Later." *Atlanta Journal/Atlanta Constitution* (17 April 1982): Weekend T6.

Puglienn, G. "Robert Mapplethorpe." *Zoom*, no. 88 (1981).

Quadri, F. "Ossessione Nera." *Panorama* (Italy) (15 June 1981): 137.

Raynor, Vivien. "Split Vision." *The New York Times* (10 January 1986): C24.

Revenga, Luis. "Las Flores Negras de Mapplethorpe, y Otros." *El Pais* (Spain) (27 April 1985).

Ricard, Rene. "Patti Smith and Robert Mapplethorpe at Miller." *Art in America* (September/October 1978): 126.

"Robert Mapplethorpe: Le portrait 'intime.'" *Photo* (France) (February 1978): 58–65.

"Robert Mapplethorpe." *The San Francisco Bay Guardian* (30 April 1980).

"Robert Mapplethorpe." *The Advocate* (24 July 1980).

"Robert Mapplethorpe." *Le Palace Magazine* (December 1981).

"Robert Mapplethorpe faire de l'art avec des tabous." *Photo-Reporter* (France) (January 1983).

"Robert Mapplethorpe." *East Village Eye* (April 1983).

"Robert Mapplethorpe." *British Journal of Photography* (25 November 1983): 1249.

"Robert Mapplethorpe." *Photo Japon* (Japan) (January 1984): 74–81.

"Robert Mapplethorpe." *Photo Japon* (Japan) (September 1986).

Robinson, Gil. "Photographer Robert Mapplethorpe Comes to Atlanta." *Gazette Newsmagazine* (8 April 1982): 3.

Rooney, Robert. "The Unambiguous Stare of Mapplethorpe's Lens." *The Australian* (25 February 1986).

Rozon, R. "The Challenges of the Salon National of the Montreal Art Galleries." *Vie des Arts* (Canada) (March 1985): 60–61.

Schjeldahl, Peter. "The Mainstreaming of Mapplethorpe, Taste and Hunger." *7 Days* (10 August 1988): 48.

Schwabe, G. "Fotograften." *Kunstwerk* (Germany) (May 1987): 88–89.

"Du Sens et du Sensuel." *Il Connaissance des Arts* (France) (March 1985): 95.

Sidlauskas, Susan. "Ambulant Architecture: The Body As Blueprint." *Alive* (September/October 1982): 26–29.

Simson, Emily. "Portraits of a Lady." *Art News* (November 1983): 53–54.

Sischy, Ingrid. "Lisa Lyon." *Artforum* (November 1980): 55–60.

Sontag, Susan. "Sontag on Mapplethorpe." *Vanity Fair* (July 1985): 68–73.

Squiers, Carol. "The Visible Face." *The Village Voice* (30 November 1982).

———. "Undressing the Issues." *The Village Voice* (5 April 1983): 81.

———. "Mapplethorpe off the Wall." *Vanity Fair* (January 1985).

———, and Steven Koch. "Mapplethorpe." *American Photographer* (January 1988): 44.

Stretch, Bonnie Barrett. "Contemporary Photography." *Art and Auction* (May 1987): 140–47.

Sturman, John. "Robert Mapplethorpe." *Art News* (November 1985): 147.

"Symboles de Mapplethorpe—Fantasmes sur le Theme de 'L'homme, Jardin de Geometrie.'" *Photo* (France) (October 1981): 112–17.

Tamblyn, Christine. "Poses and Positions." *Artweek* (27 June 1987): 11.

Tatransky, Valentin. "Robert Mapplethorpe." *Arts Magazine* (April 1977): 29.

Thornton, Gene. "This Show Is a Walk Down Memory Lane." *The New York Times* (28 September 1983): 2.27.

Tobias, Tobi. "Mixed Blessings." *New York* (17 February 1986): 116.

Trucco, Terry. "State of the Art: Print Sales in Cameraland." *American Photographer* (January 1984): 18.

van Ginneken, L. "Mapplethorpe." *De Volkskrant* (Germany) (18 May 1979).

Vormese, Francine. "Lisa Lyon, Une Force de La Nature." *Elle* (France), no. 1947.

Walker, Anne. "Holly Solomon/Robert Mapplethorpe." Interview. *Shift,* no. 1 (1987): 18–19.

Weaver, Mike. "Mapplethorpe's Human Geometry: A Whole Other Realm." *Aperture* (Winter 1985): 42–51.

Welch, M. "Mapplethorpe's Garden, Manhattan Fleurs du Mal." *New Art Examiner* (January 1982).

Whelan, Richard. "Robert Mapplethorpe: Hard Sell, Slick Image." *Christopher Street* (June 1979): 17–19.

White, Edmund. "The Irresponsible Art of Robert Mapplethorpe." *The Sentinel* (5 September 1980).

Zaya. "Los 'Negros Viriles' de Robert Mapplethorpe." *Los Cuadernos del Norte* (Spain) (January/February 1983): 12–13.

Zelavansky, Lynn. "Robert Mapplethorpe: Leo Castelli." *Flash Art* (Summer 1983): 63–64.

Zellweger, Harry. "Ausstellungs—Ruckschau: London." *Das Kunstwerk* (Germany) (February 1984): 30.

SELECTED BOOKS

Barnes, Lawrence, ed. *The Male Nude in Photography.* Introduction by Marcuse Pfeifer. Waisfield, Vermont: Vermont Crossroads Press, 1980.

Barthes, Roland. *La Camera Lucida: Reflections on Photography.* Translation by Richard Howard. New York: Hill and Wang, 1981.

Celant, Germano. *Artmakers: Art, Architecture, Photography, Dance, and Music in the U.S.A.* Milan: Feltrinelli, 1984.

Clyne, Jim, ed. *Exquisite Creatures.* New York: William Morrow and Company, 1985.

Contemporary American Erotic Photography. Vol. 1. Los Angeles: Melrose, 1984.

Frank, Peter, ed. *Dact: An Anthology of Art Criticism.* New York: Willis, Locker & Owens, 1984.

Minkkinen, A. R. *New American Nudes.* New York: Morgan & Morgan, 1982.

Naef, Weston J., and Belinda Rathbone, eds. *The Gallery of World Photography/New Directions.* Tokyo: Shueisha Publishing, 1984.

Smith, Patti. *Robert Mapplethorpe.* Bellport, New York: Bellport Press, 1987.

Sullivan, Constance, ed. *Legacy of Light.* Introduction by Peter Schjeldahl, essays by Gretel Ehrlich, Robert Stone, Richard Howard, and Diane Johnson. New York: Alfred A. Knopf, 1987.

————. *Nude: Photographs, 1850–1980.* Essays by Robert Sobieszek and Ben Maddow. New York: Harper and Row, 1980.

Wise, Kelly, ed. *Portrait: Theory.* New York: Lustrum Press, 1982.

SELECTED EXHIBITION CATALOGUES

Amaya, Mario. *Robert Mapplethorpe Photographs.* Norfolk, Virginia: Chrysler Museum, 1978.

Augur, Julie. *American Portraits of the Sixties and Seventies.* Aspen, Colorado: Aspen Center for the Visual Arts, 1979.

Barendse, Henry. *The Fashionable Image: Unconventional Fashion Photography.* Charlotte, North Carolina: Mint Museum, 1986.

Barents, Els. *Robert Mapplethorpe.* Amsterdam: Stedelijk Museum, 1988.

————, in collaboration with Karel Schampers. *Instant Fotografie.* Amsterdam: Stedelijk Museum, 1981.

Barter, Judith, and Anne Mochon. *Rules of the Game: Culture Defining Gender.* Amherst, Massachusetts: Mead Art Museum, Amherst College, 1986.

Bookhardt, Eric D. *Radical Photography: The Bizarre Image.* Atlanta: Nexus Gallery, 1984.

Borden, Janet. *Presentation: Recent Portrait Photography.* Cincinnati: Taft Museum, 1983.

Cathcart, Linda, and Craig Owens. *The Heroic Figure.* Houston: Contemporary Arts Museum, 1984.

Celant, Germano. *Robert Mapplethorpe Fotografie.* Milan: Milano Idea Books Edizioni; Venice: Centro di Documentazione di Palazzo Fortuny, 1983.

————. *Robert Mapplethorpe.* Piran, Yugoslavia: Obalne Galerije, 1986.

Collingnon, Robert, et al. *Figures: Forms and Expressions.* Buffalo: Albright-Knox Art Gallery, 1981.

Compton, Michael. *New Art.* London: The Tate Gallery, 1983.

Conrad, Peter. *Mapplethorpe Portraits.* London: National Portrait Gallery Publications, 1988.

Cruger, George. *Portrait: Faces of the '80s.* Richmond, Virginia: Virginia Museum of Fine Arts, 1987.

Curtis, Verna Posever, Russell Bowman, and Robert M. Tilendis. *Of People and Places: The Floyd and Josephine Segal Collection of Photography.* Milwaukee: Milwaukee Art Museum, 1987.

Dugan, Ellen. *First Person Singular: Self-Portrait Photography, 1840–1987.* Atlanta: High Museum at Georgia-Pacific Center, 1988.

Fernandes, Joyce. *Sex-Specific: Photographic Investigations of Contemporary Sexuality.* Chicago: School of the Art Institute of Chicago, 1984.

Foss, Paul. *Robert Mapplethorpe: Photographs 1976–1985.* South Yarra: Australian Center for Contemporary Art, 1986.

Frank, Peter. *Self-Portraits.* Seattle: Linda Farris Gallery, 1983.

Friis-Hansen, Dana, with essay by Carrie Rickey. *Nude, Naked, Stripped.* Cambridge: Hayden Gallery, List Visual Arts Center, Massachusetts Institute of Technology, 1985.

Fuchs, Rudi. *documenta 7.* Kassel, West Germany: documenta, 1982.

Gamwell, Lynn. *Inside Out—Self Beyond Likeness.* Newport Beach, California: Newport Harbor Museum, 1981.

Hartshorn, Willis. *Art & Advertising, Commercial Photography by Artists.* New York: International Center of Photography, 1986.

Hedberg, Lars Peder. *US Art Now.* Stockholm: Nordiska Kompaniet, 1981.

Holmes, Jon. *Twelve on 20 × 24.* Cambridge: New England Foundation for the Arts, 1984.

Horton, Anne. Interview. *Robert Mapplethorpe 1986.* Berlin: Raab Galerie; Cologne: Kicken-Pauseback, 1986.

Kardon, Janet, David Joselit, Kay Larson, and Patti Smith. *Robert Mapplethorpe: The Perfect Moment*. Philadelphia: Institute of Contemporary Art, University of Pennsylvania, 1988.

Lifson, Ben. *Faces Photographed*. New York: Grey Art Gallery and Study Center, New York University, 1982.

Livingston, Jane. *The Collection of Sam Wagstaff*. Washington, D.C.: Corcoran Gallery of Art, 1977.

Longwell, Dennis. *Surrealist Photographic Portraits 1920–1980*. New York: Marlborough Gallery, 1981.

Macklowe, Linda. *Flower As Image in 20th-Century Photography*. Bronx, New York: Wave Hill, 1984.

Marincola, Paula. *Investigations 10, Face to Face: Recent Portrait Photography*. Philadelphia: Institute of Contemporary Art, University of Pennsylvania, 1984.

Marshall, Richard, Richard Howard, and Ingrid Sischy. *Robert Mapplethorpe*. New York: Whitney Museum of American Art, in association with New York Graphic Society Books, Little, Brown and Co., 1988.

Mayer, Charles S., and Bert Brouwer. *intimate/INTIMATE*. Terre Haute: Turman Gallery, Indiana State University, 1986.

Morgan, Stuart, and Alan Hollinghurst. *Robert Mapplethorpe, 1970–1983*. London: Institute of Contemporary Arts, 1983.

Naef, Weston J. *Counterparts: Form and Emotion in Photographs*. New York: Metropolitan Museum of Art, in association with E. P. Dutton, 1982.

Olander, William. *Picture Taking: Weegee, Walker Evans, Sherrie Levine, Robert Mapplethorpe*. Evanston, Illinois: Mary and Leigh Block Gallery, Northwestern University, 1985.

Parker, Fred. *Attitudes*. Santa Barbara, California: Santa Barbara Museum of Art, 1979.

Photographs from the Collection of Robert Mapplethorpe. New York: Sotheby Parke Bernet Inc., 1982.

Saul, Julie M. *Photography in America 1910–1983*. Tampa, Florida: Tampa Museum, 1983.

Schneckenburger, Manfred. *documenta 6*. Kassel, West Germany: documenta, 1977.

Sheftel, Bruce. *Presences: The Figure and Manmade Environments*. Reading, Pennsylvania: Freedman Gallery, Albright College, 1980.

Sidlauskas, Susan. *Intimate Architecture: Contemporary Clothing Design*. Cambridge: Hayden Gallery, List Visual Arts Center, Massachusetts Institute of Technology, 1982.

Squiers, Carol. *Quattro Fotografi Differenti*. Milan: Padiglione d'Arte Contemporanea and Idea Editions, 1980.

Szarkowski, John. *Mirrors and Windows: American Photography Since 1960*. New York: Museum of Modern Art, 1978.

von der Fuhr, Rein. *Robert Mapplethorpe*. Amsterdam: Galerie Jurka, 1979.

Wagstaff, Sam. Introduction. *Robert Mapplethorpe Flowers*. Tokyo: Galerie Watari, 1983.

———, and Peter Weiermair. *Robert Mapplethorpe*. Frankfurt am Main: Frankfurter Kunstverein, 1981.

Walsh, Philip Hotchkiss, et al. *Phototypes*. New York: Whitney Museum of American Art Downtown, 1983.

White, Edmund. Introduction. *Black Males*. Amsterdam: Galerie Jurka, 1980.

Whitney Museum of American Art. *1981 Biennial*. New York: Whitney Museum of American Art, 1981.